Color My Mandalas 2

LOUISE ATHERTON

2017 Louise Atherton
louiseathertoncoloring.wordpress.com

All rights reserved.
ISBN: 1545232210
ISBN-13: 978-1545232217

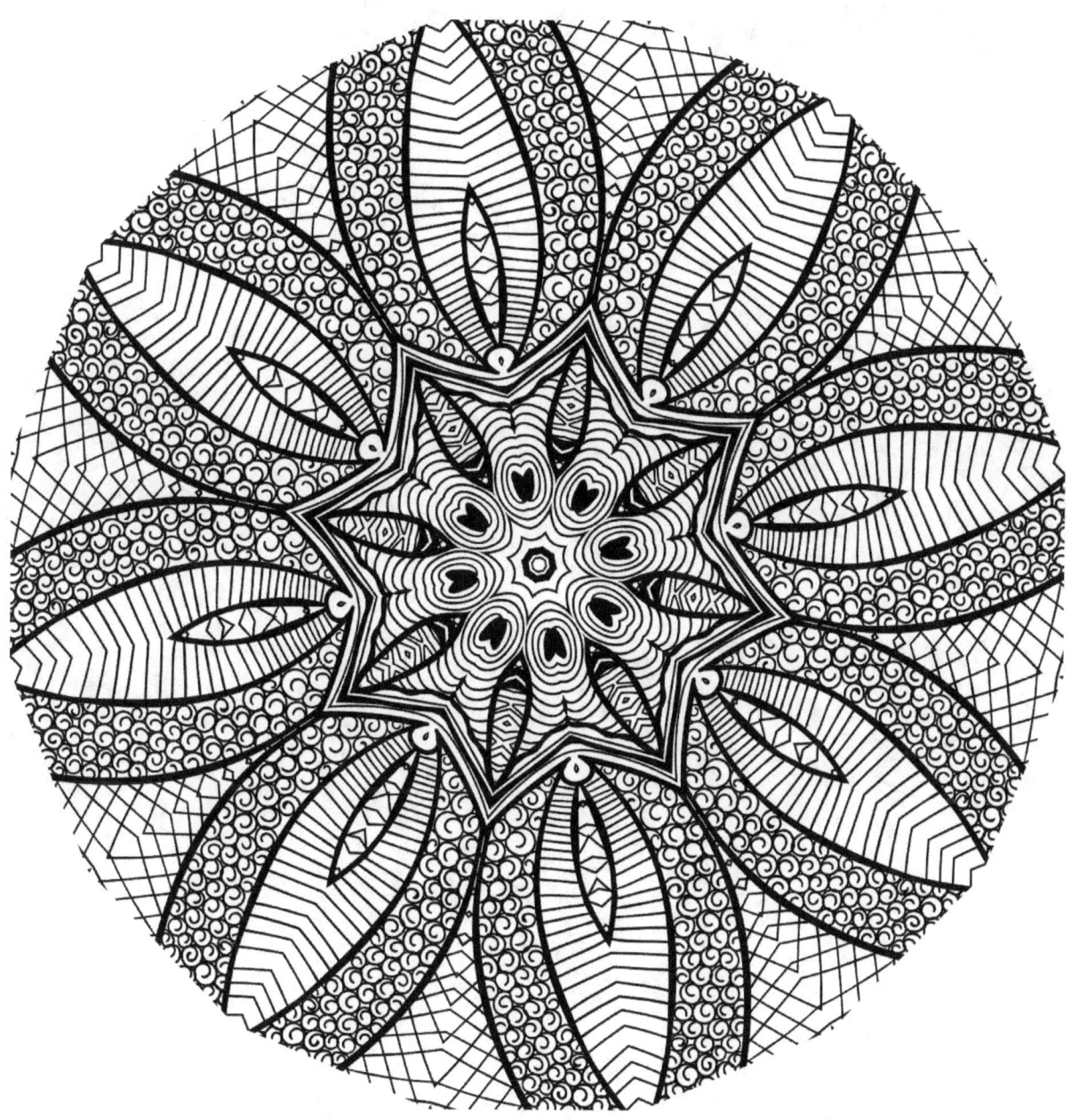

LOUISE ATHERTON

Narrow

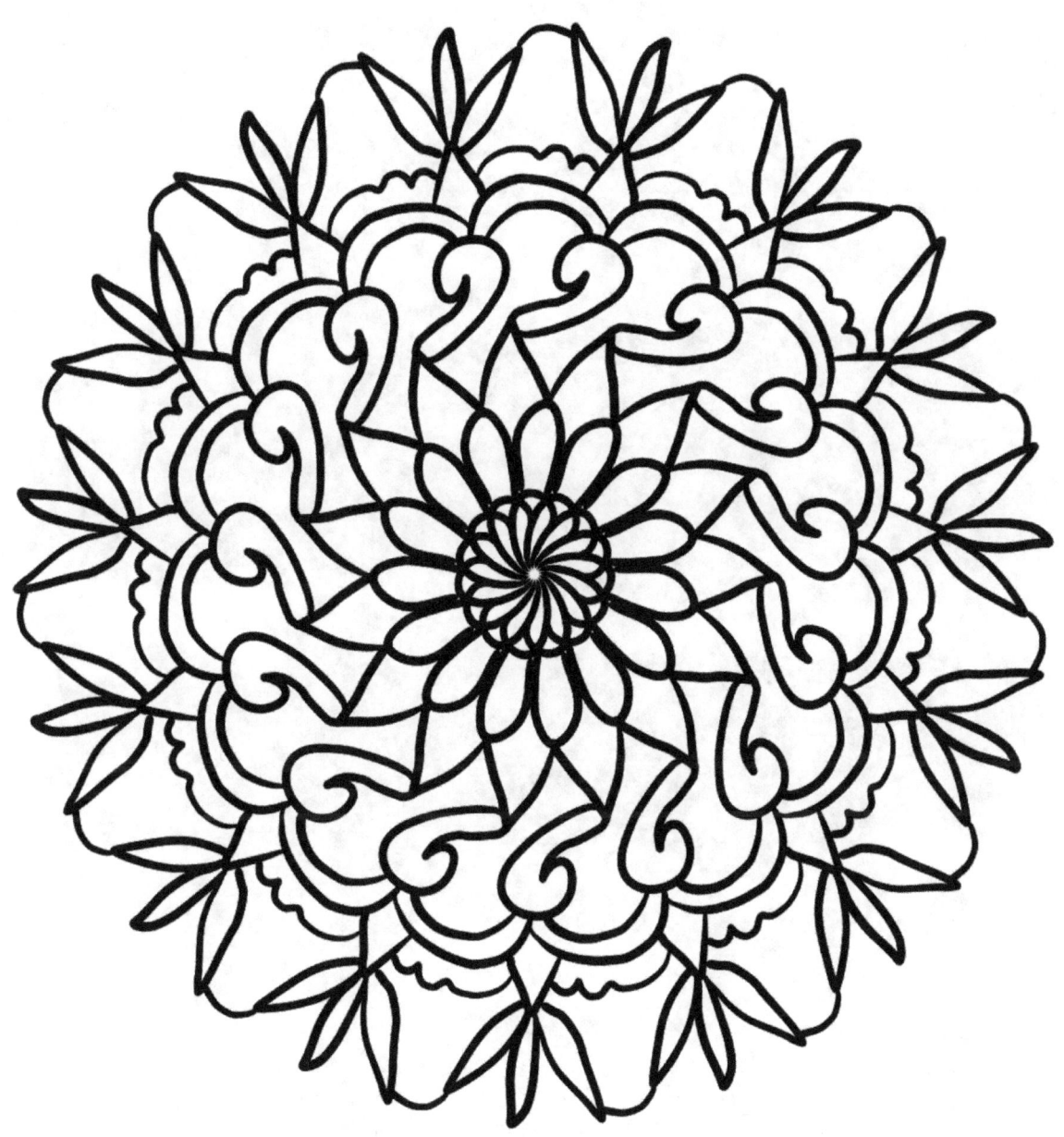

LOUISE ATHERTON

Devour

COLOR MY MANDALAS 2

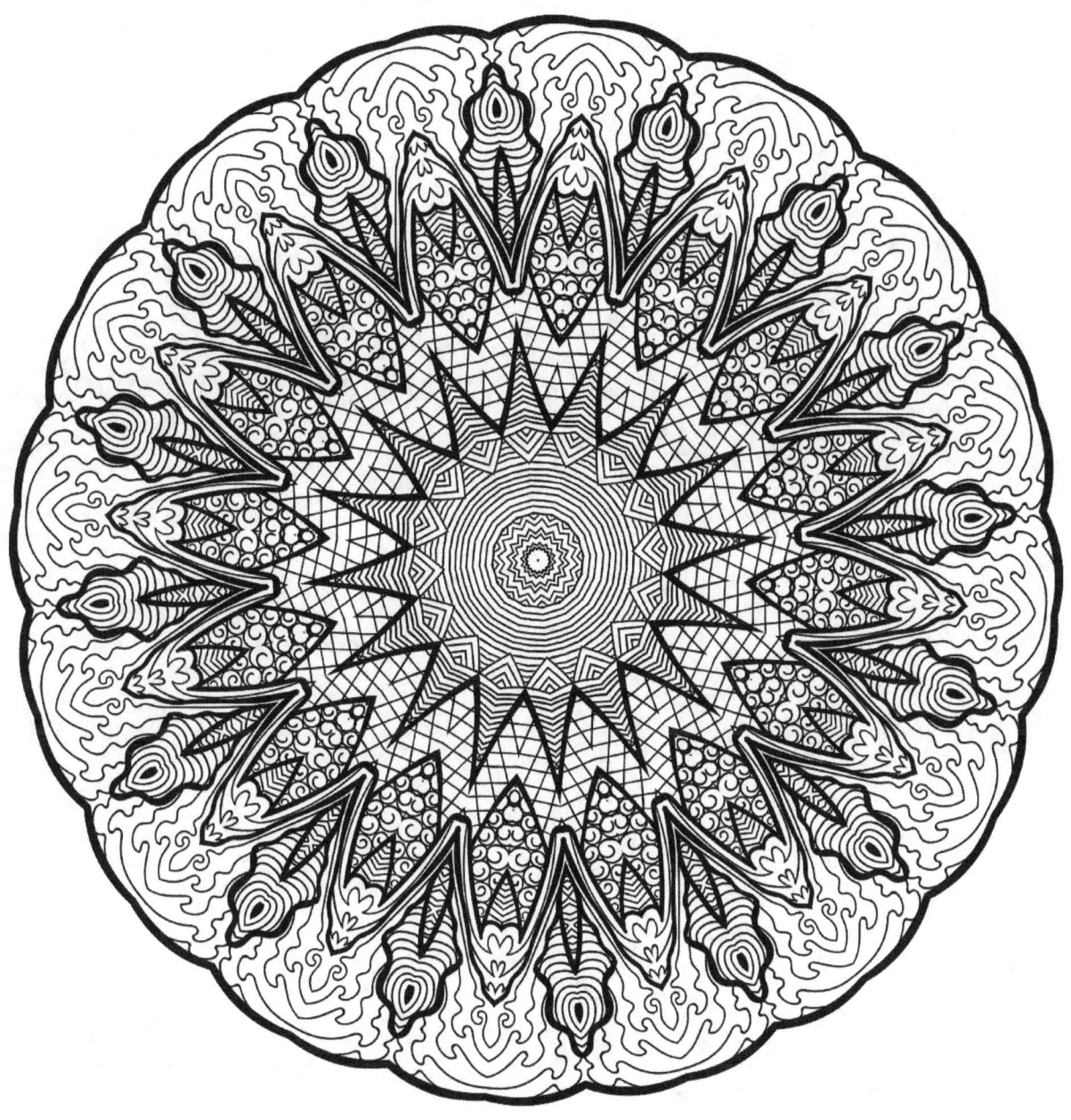

LOUISE ATHERTON

Embrace

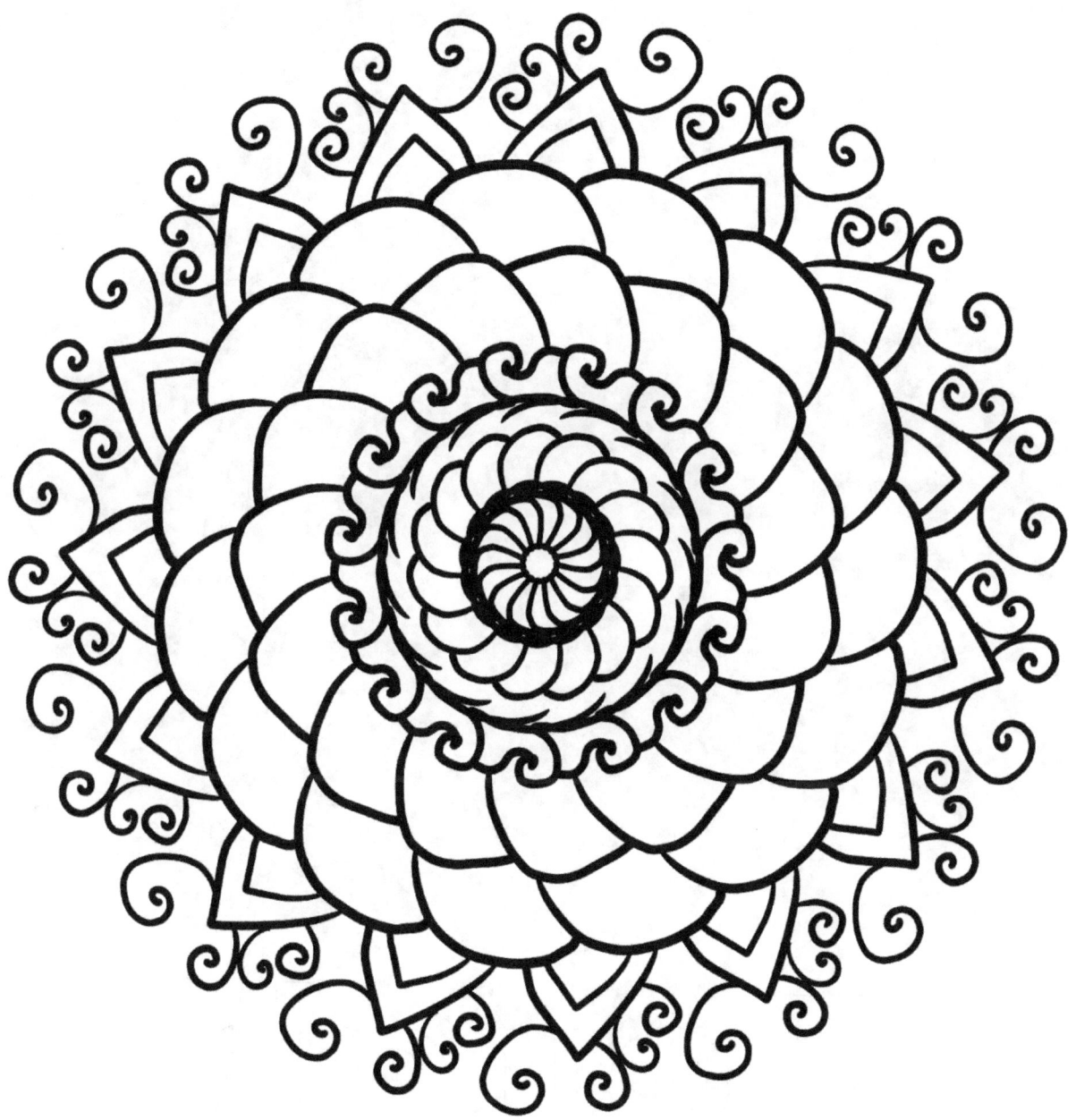

LOUISE ATHERTON

Touch

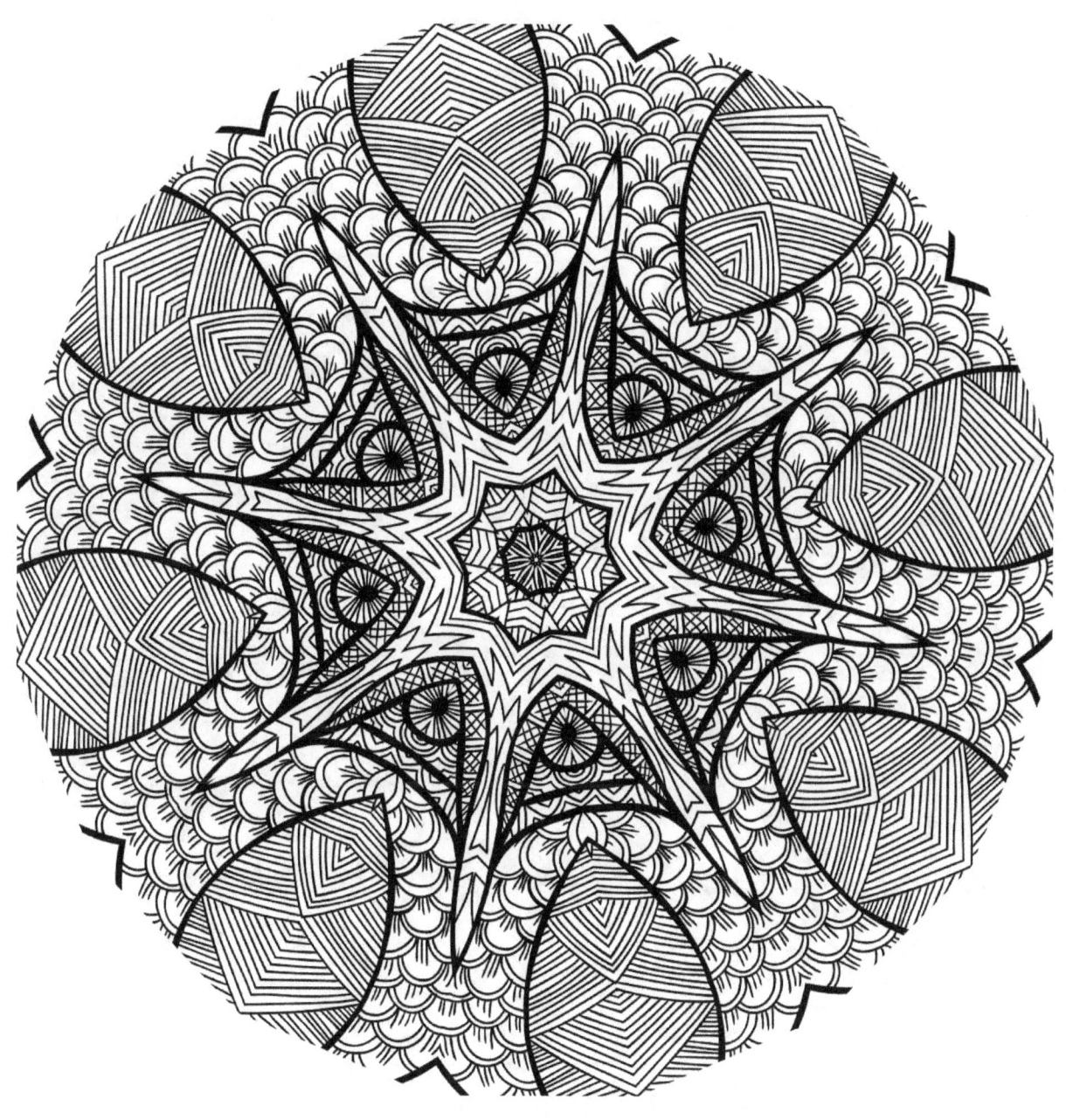

LOUISE ATHERTON

Kiss

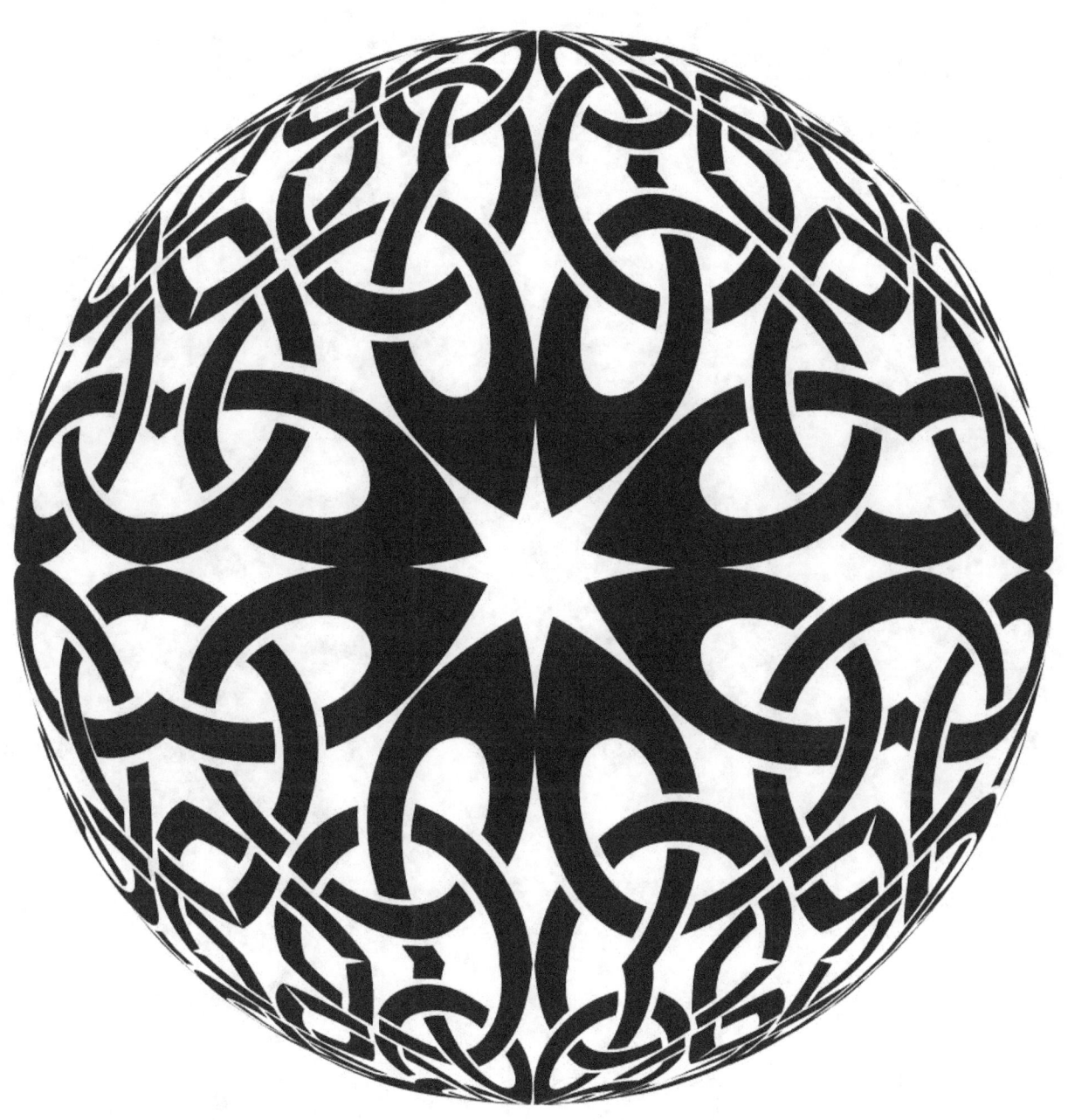

Starting

COLOR MY MANDALAS 2

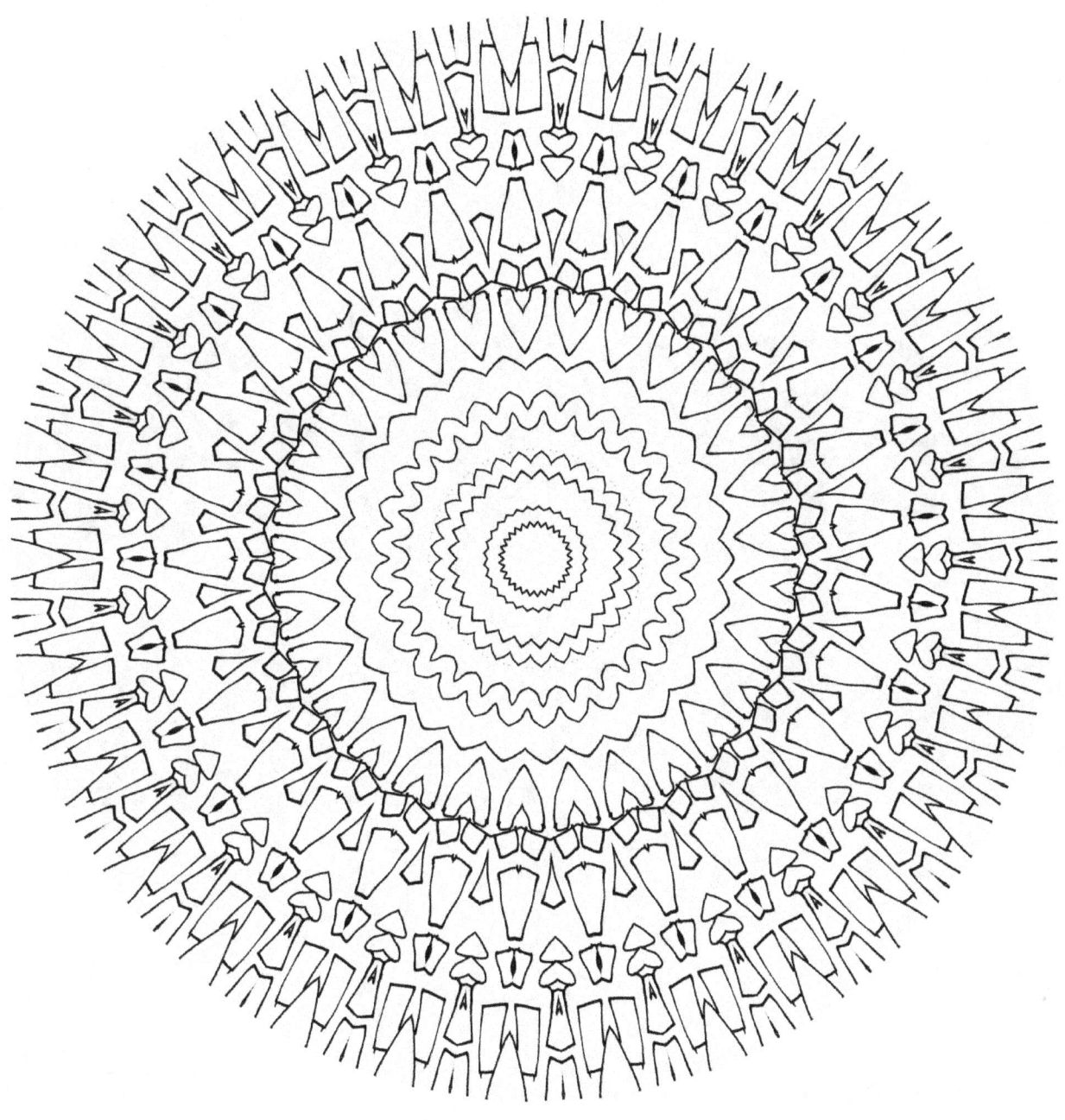

Falling

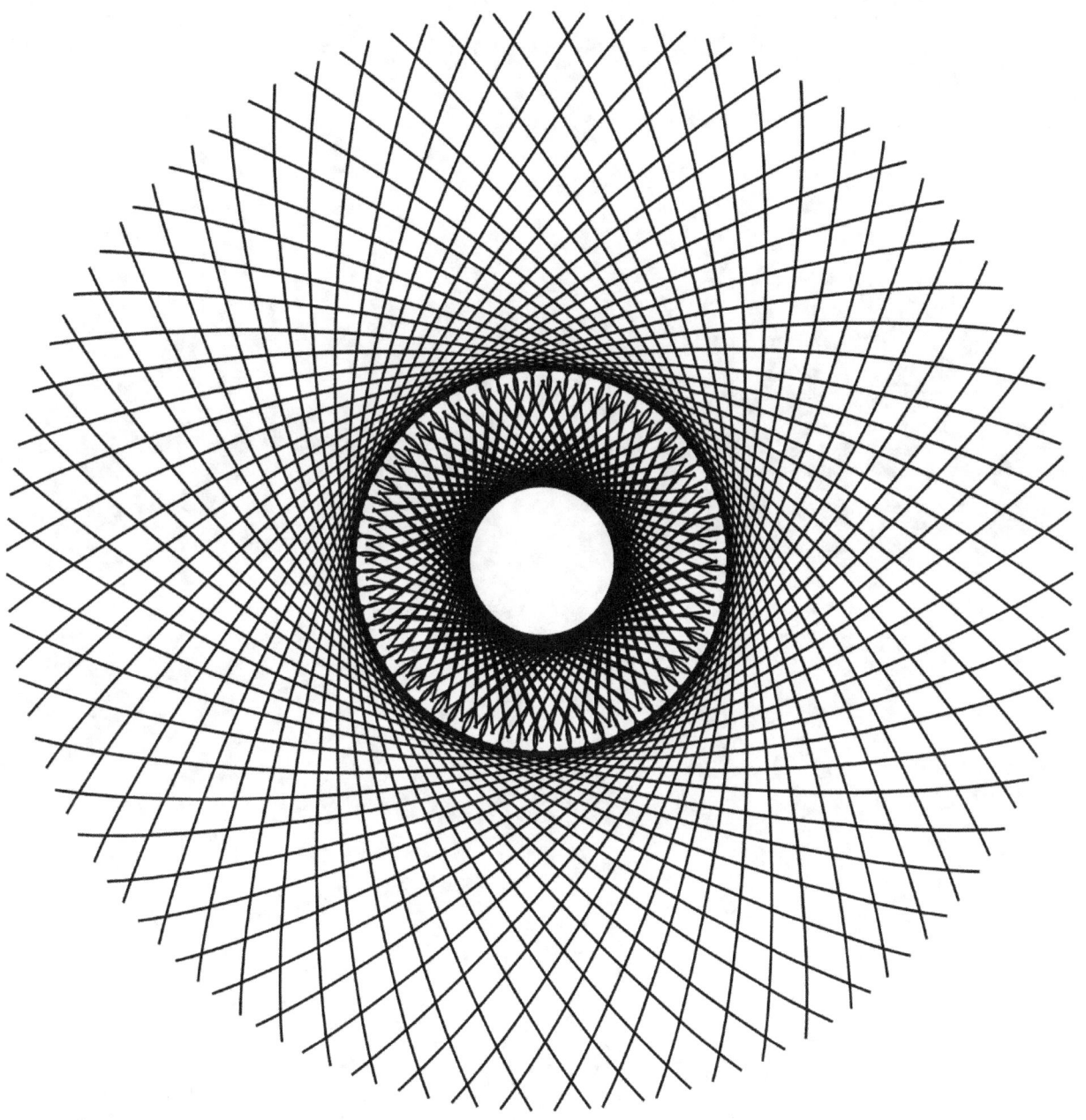

LOUISE ATHERTON

Knowing

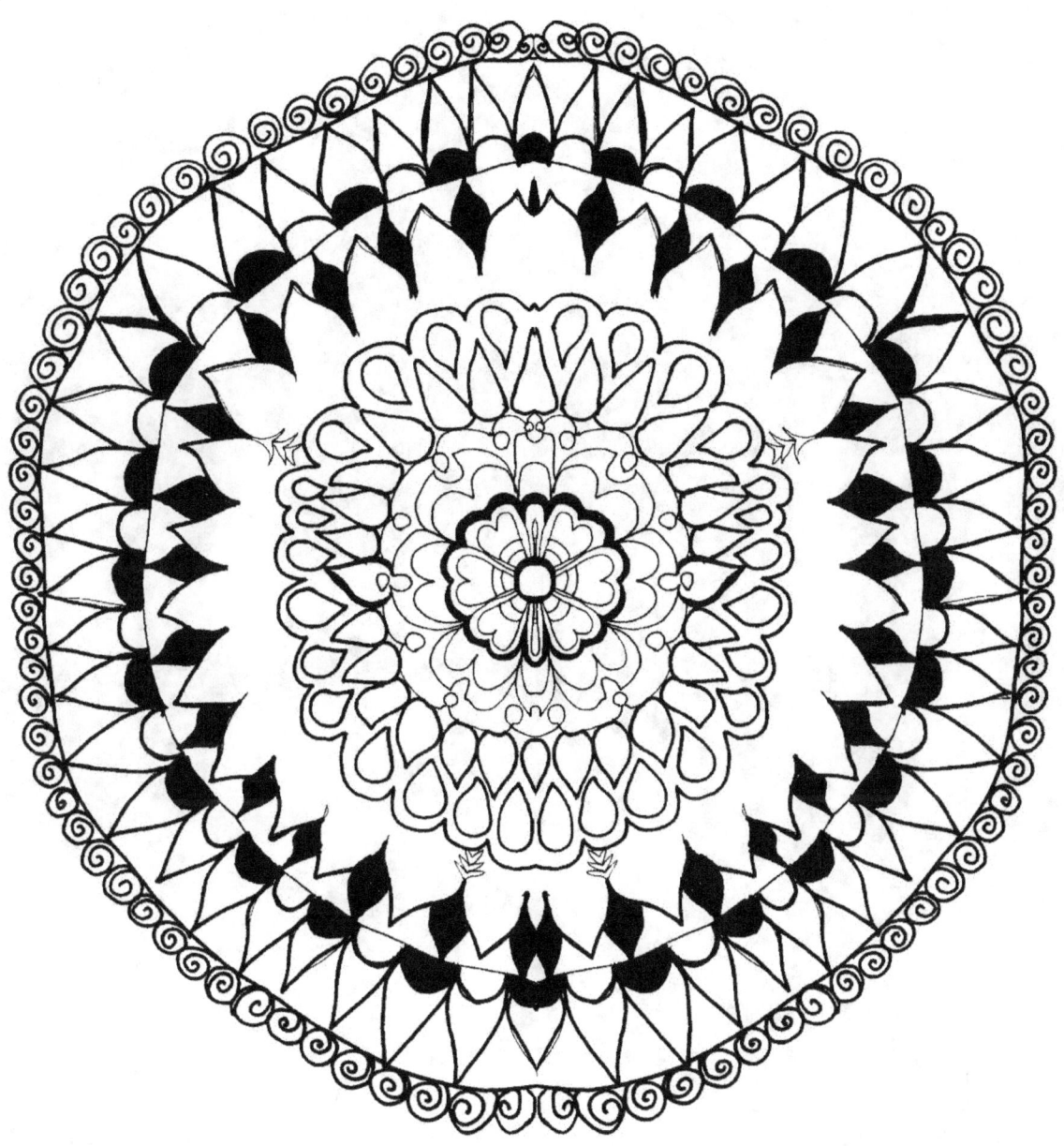

Tremble

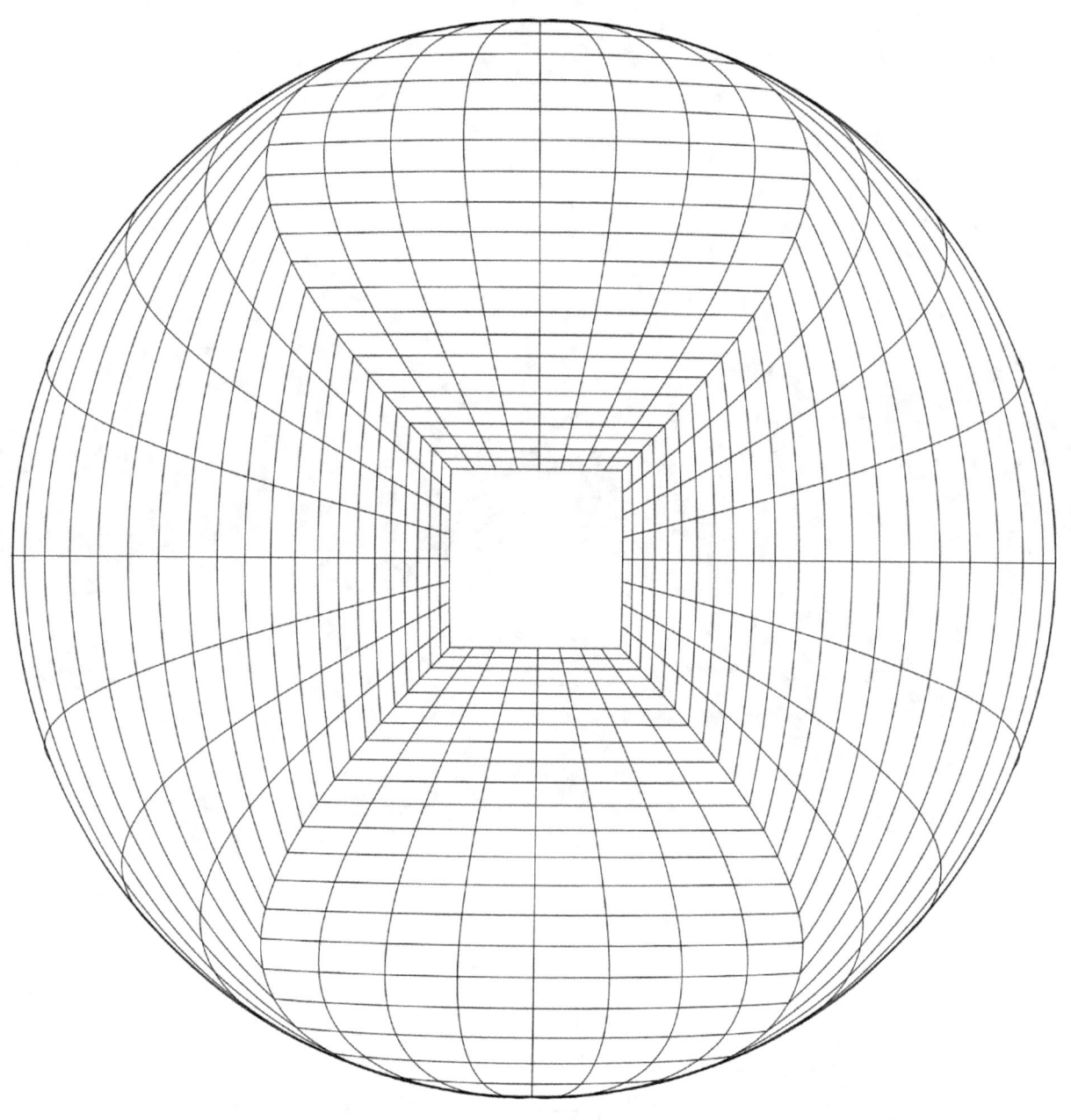

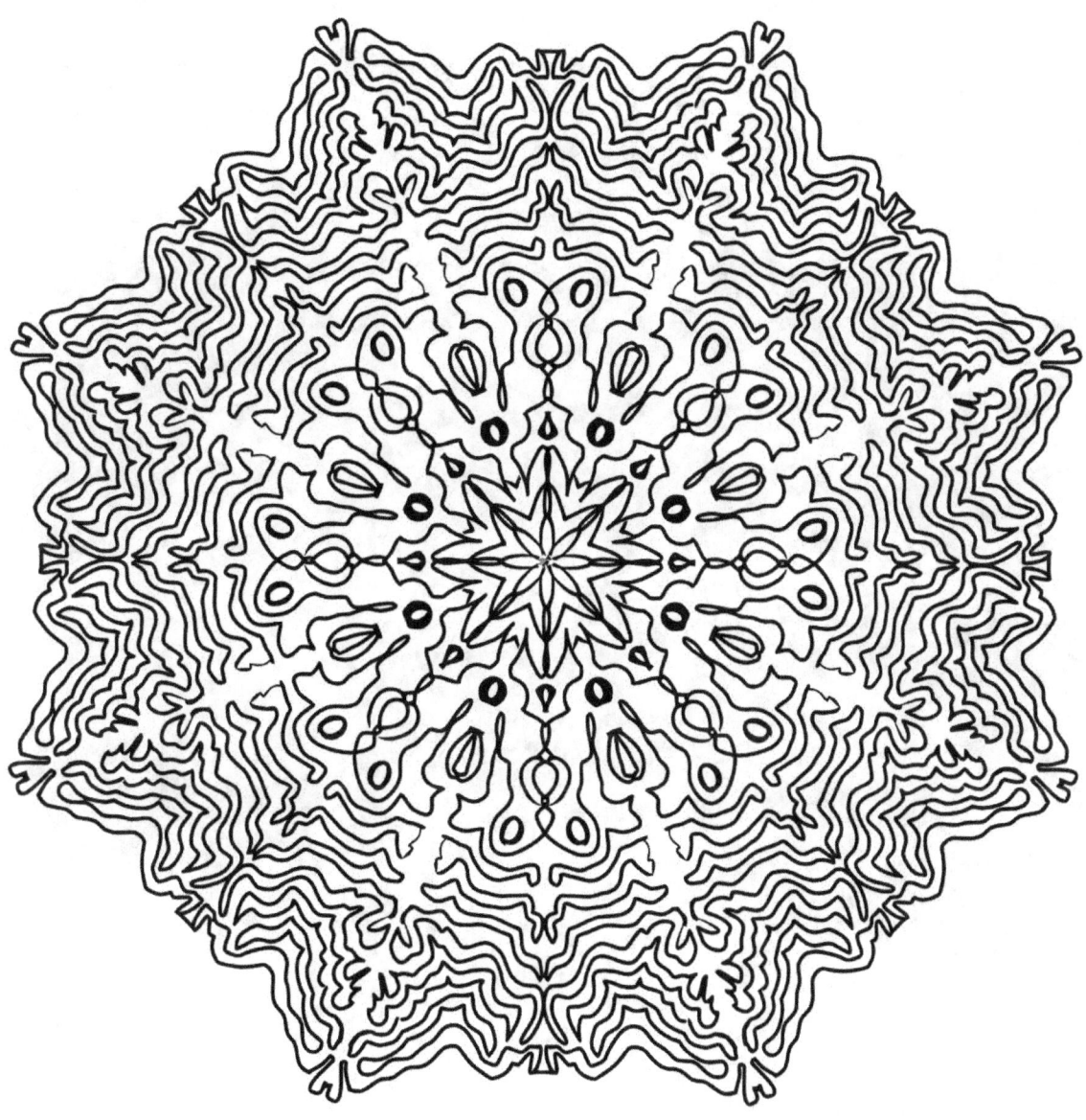

LOUISE ATHERTON

Compassionate

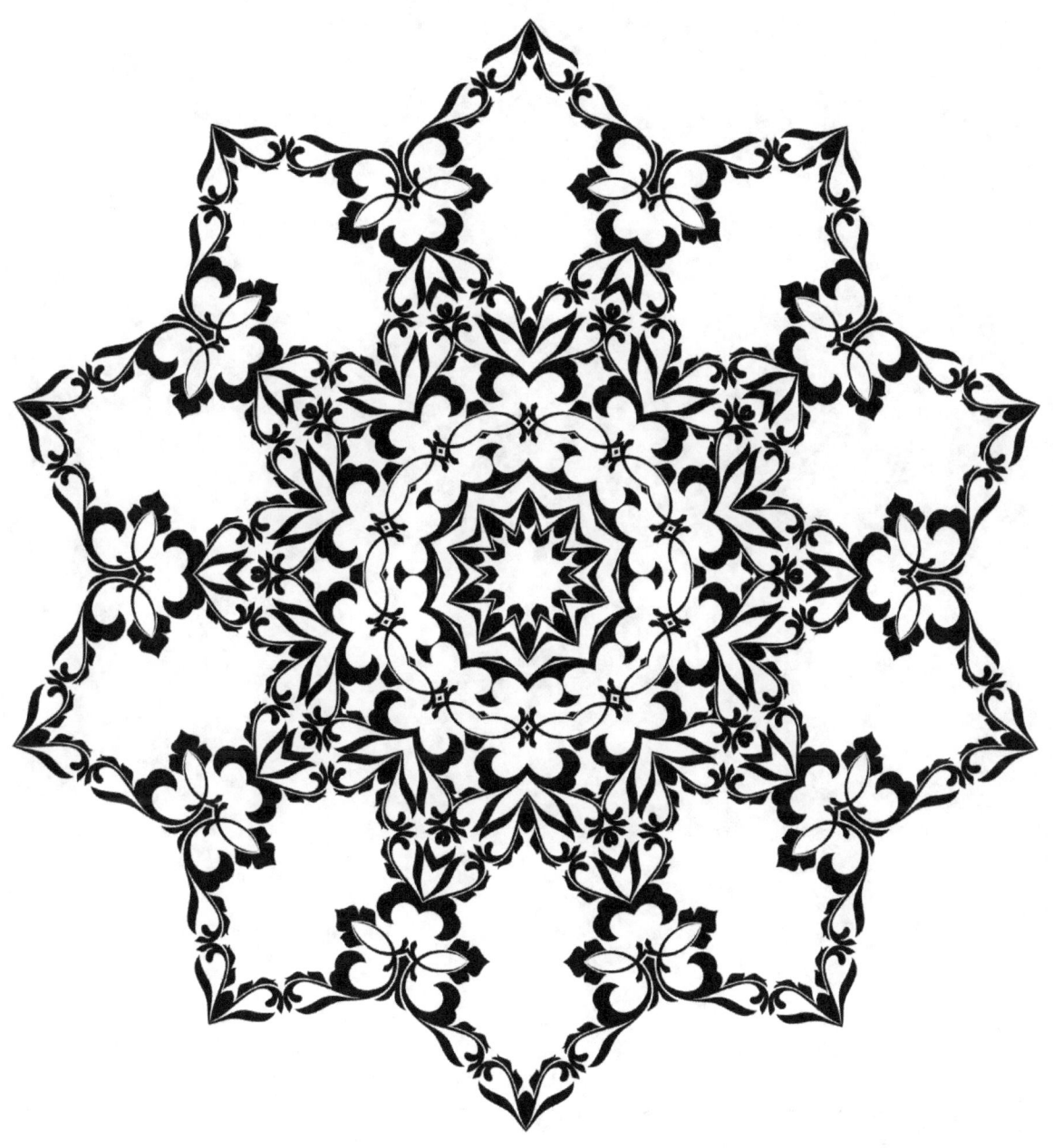

Tranquility

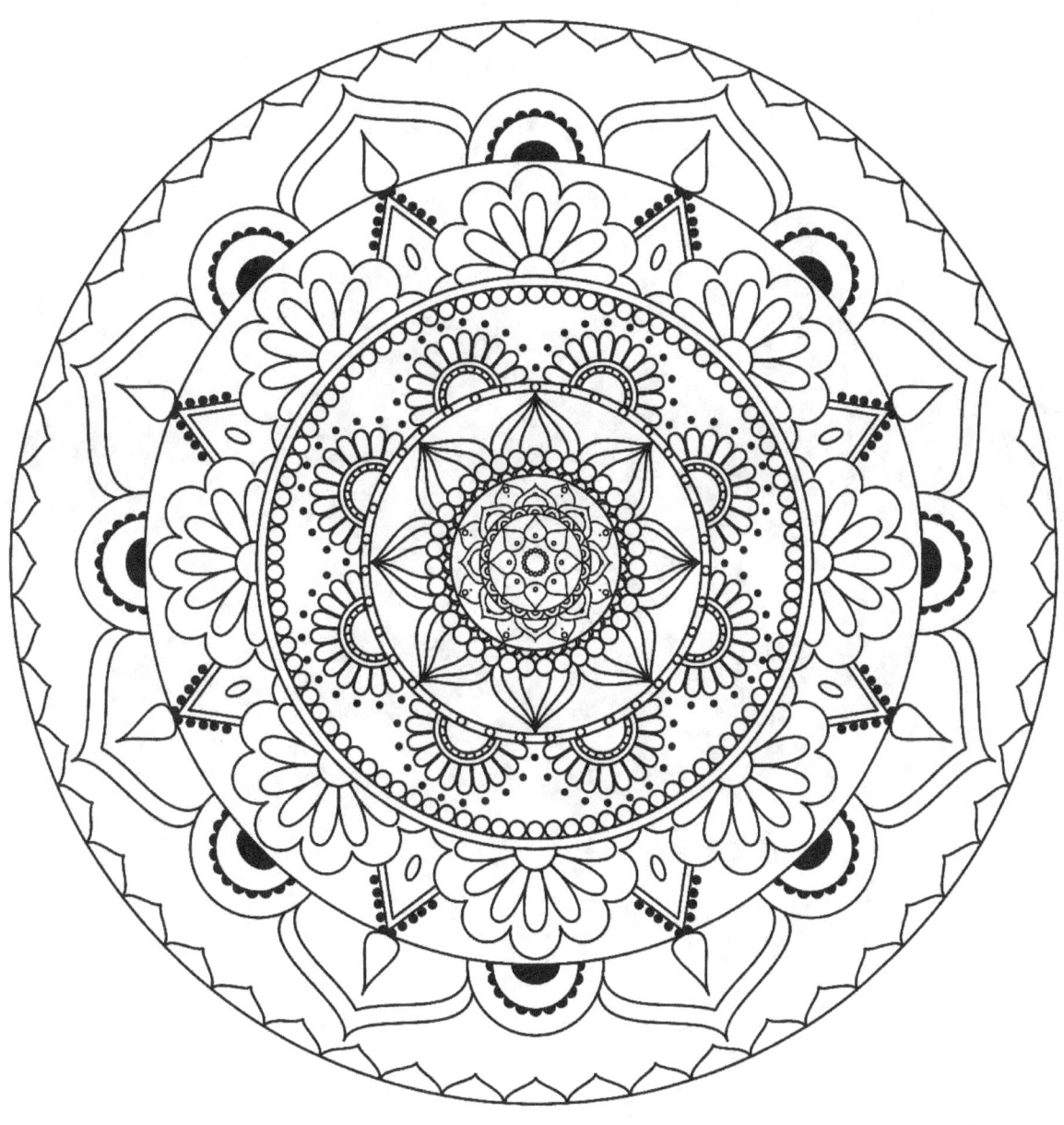

LOUISE ATHERTON

Stability

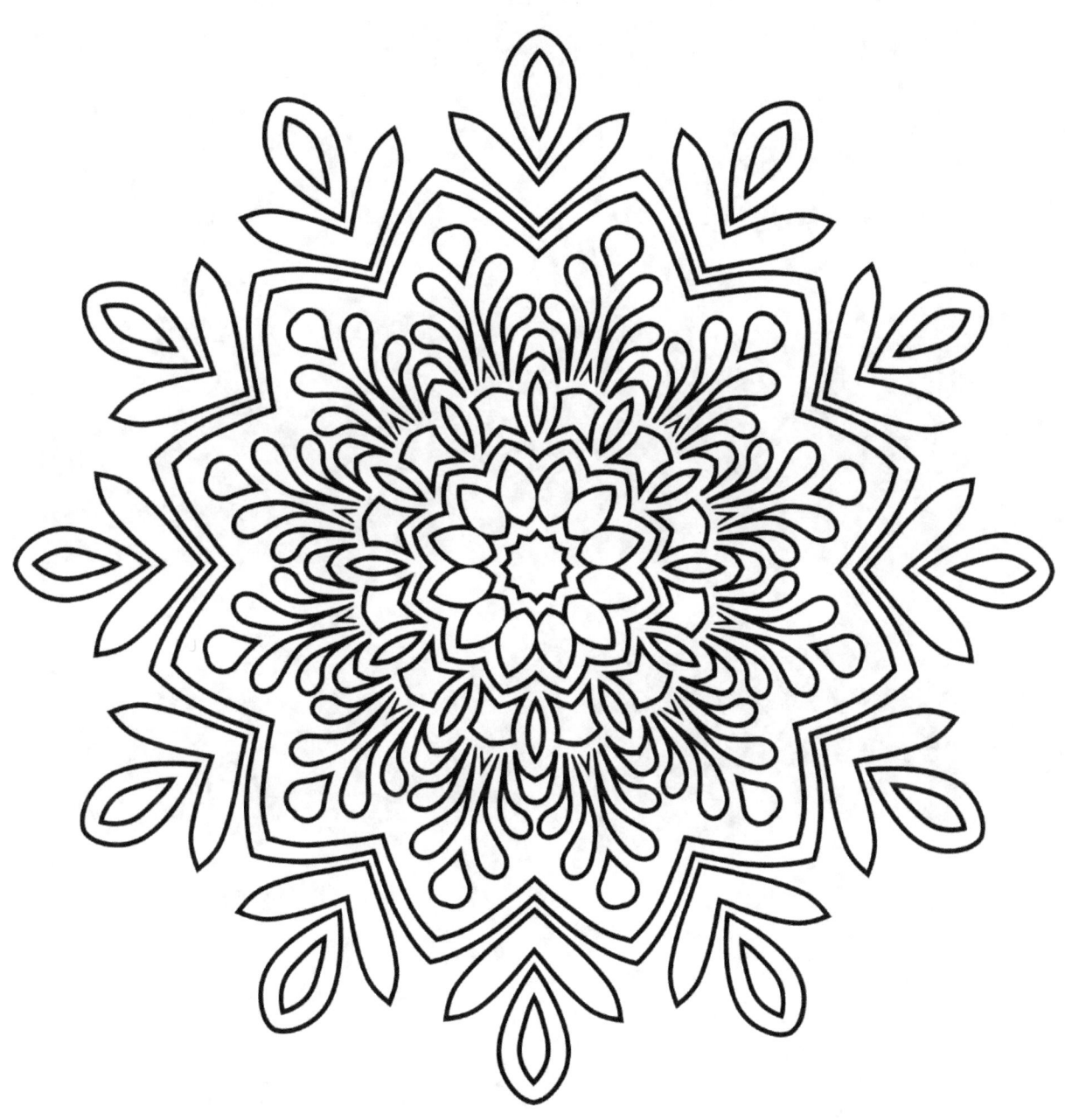

LOUISE ATHERTON

Placid

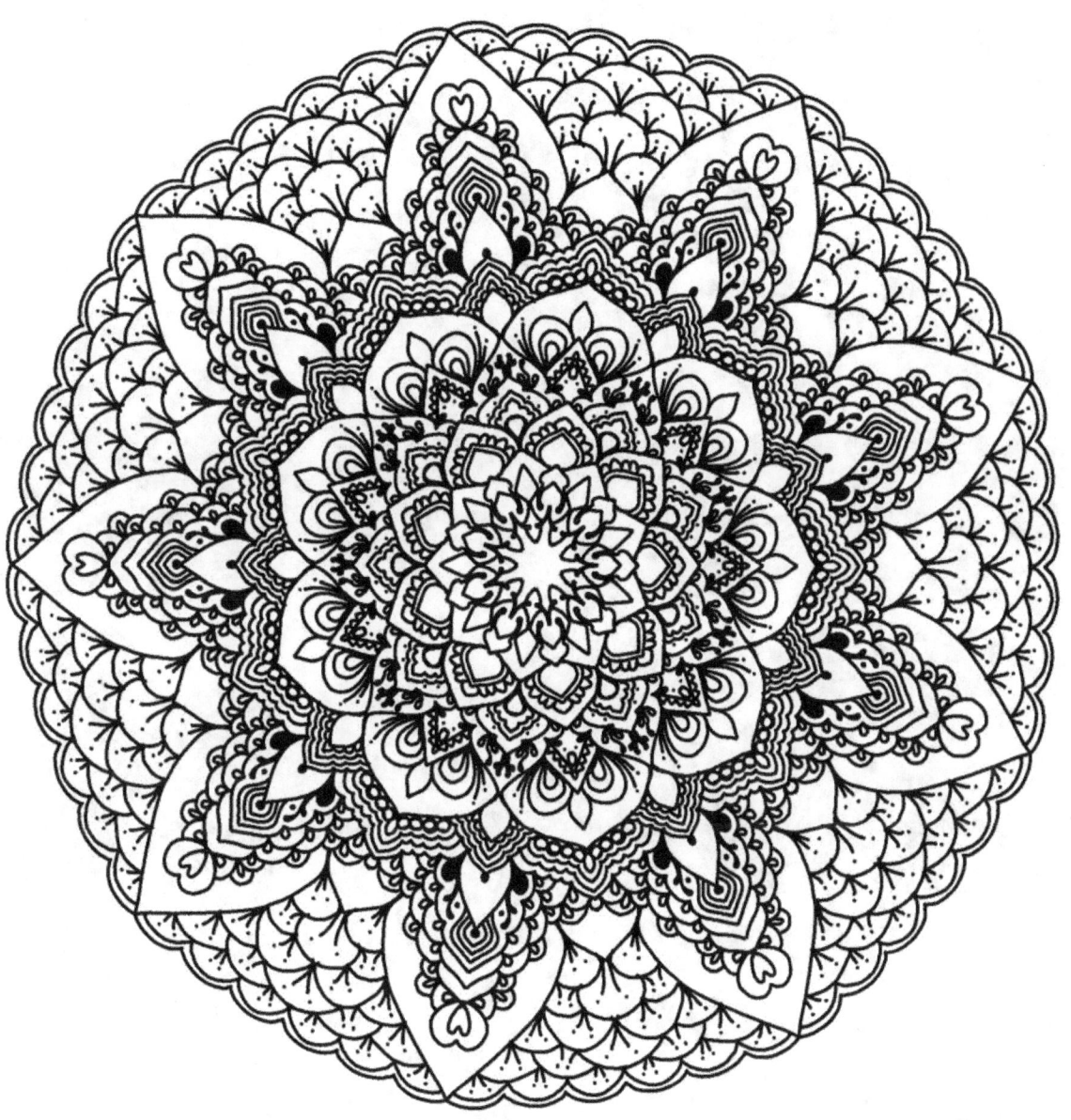

Serenity

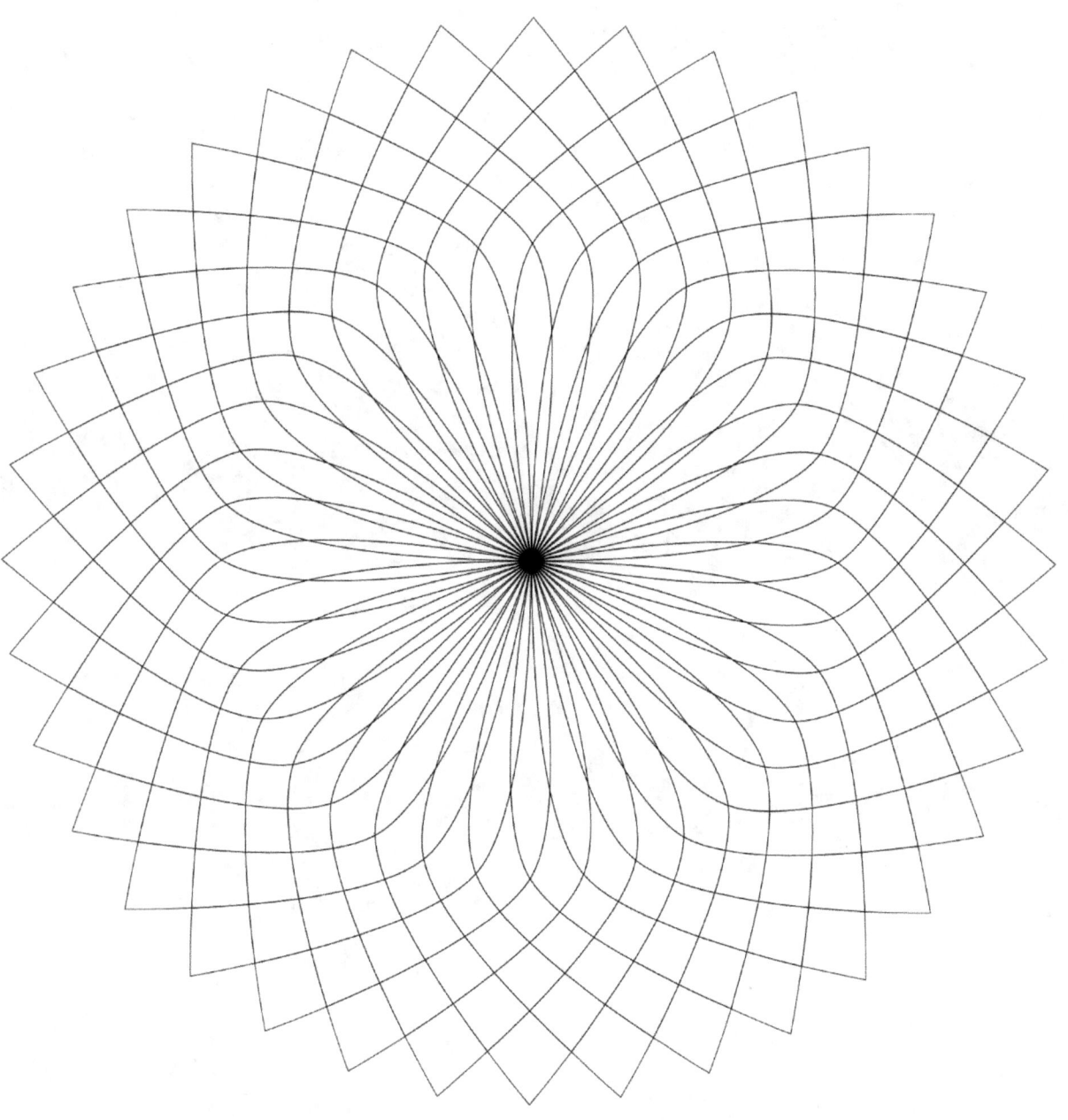

LOUISE ATHERTON

Sympathy

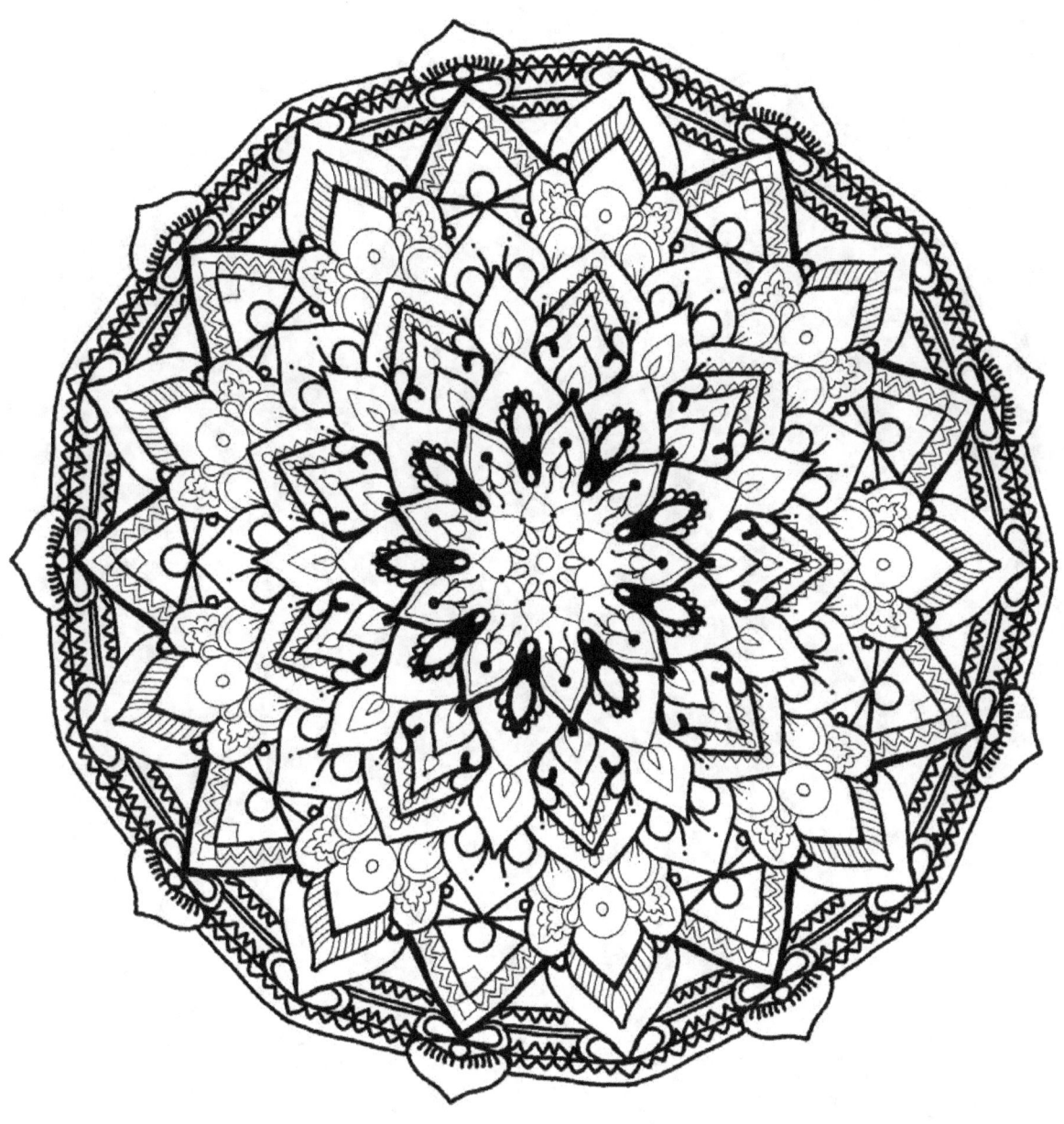

Empathy

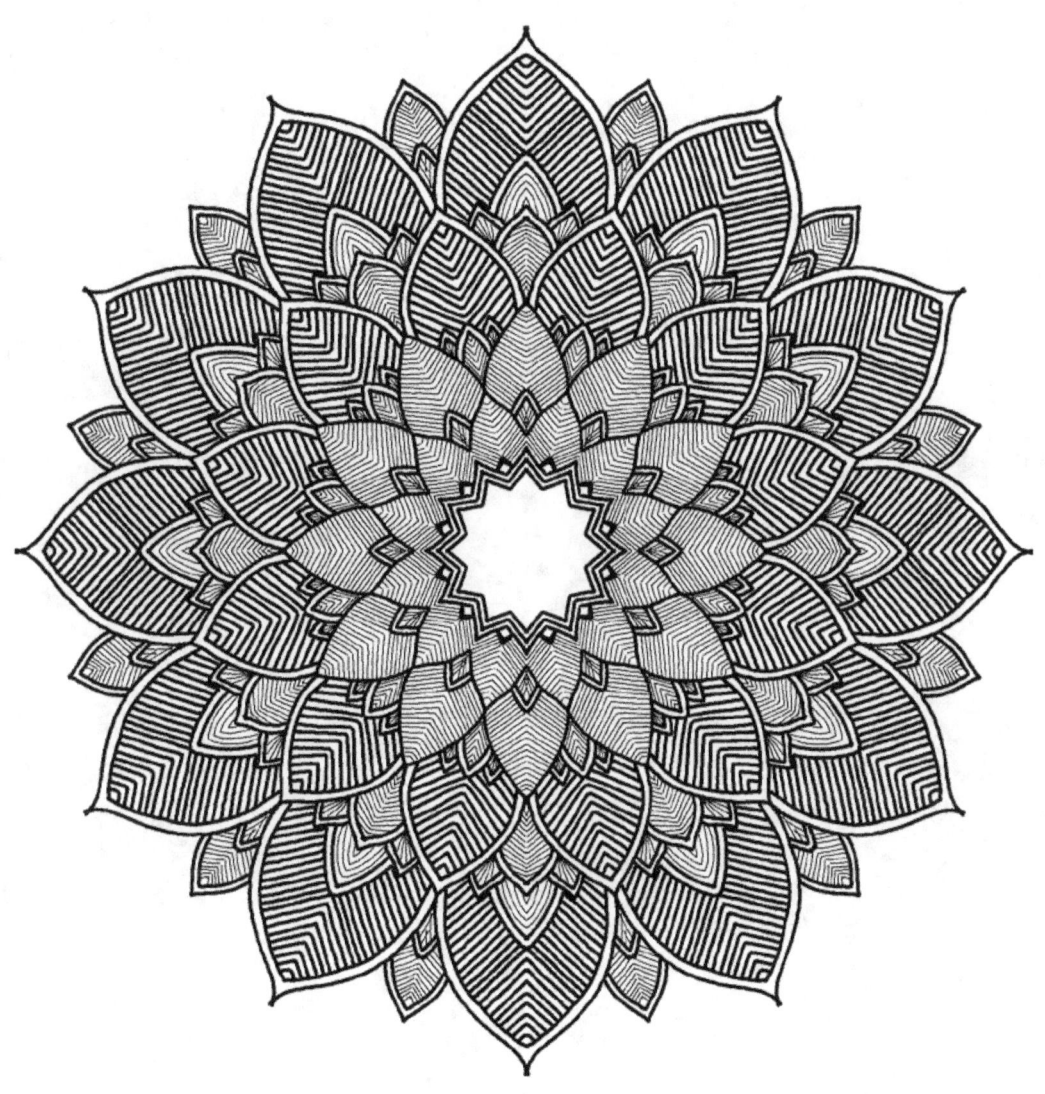

LOUISE ATHERTON

Feat

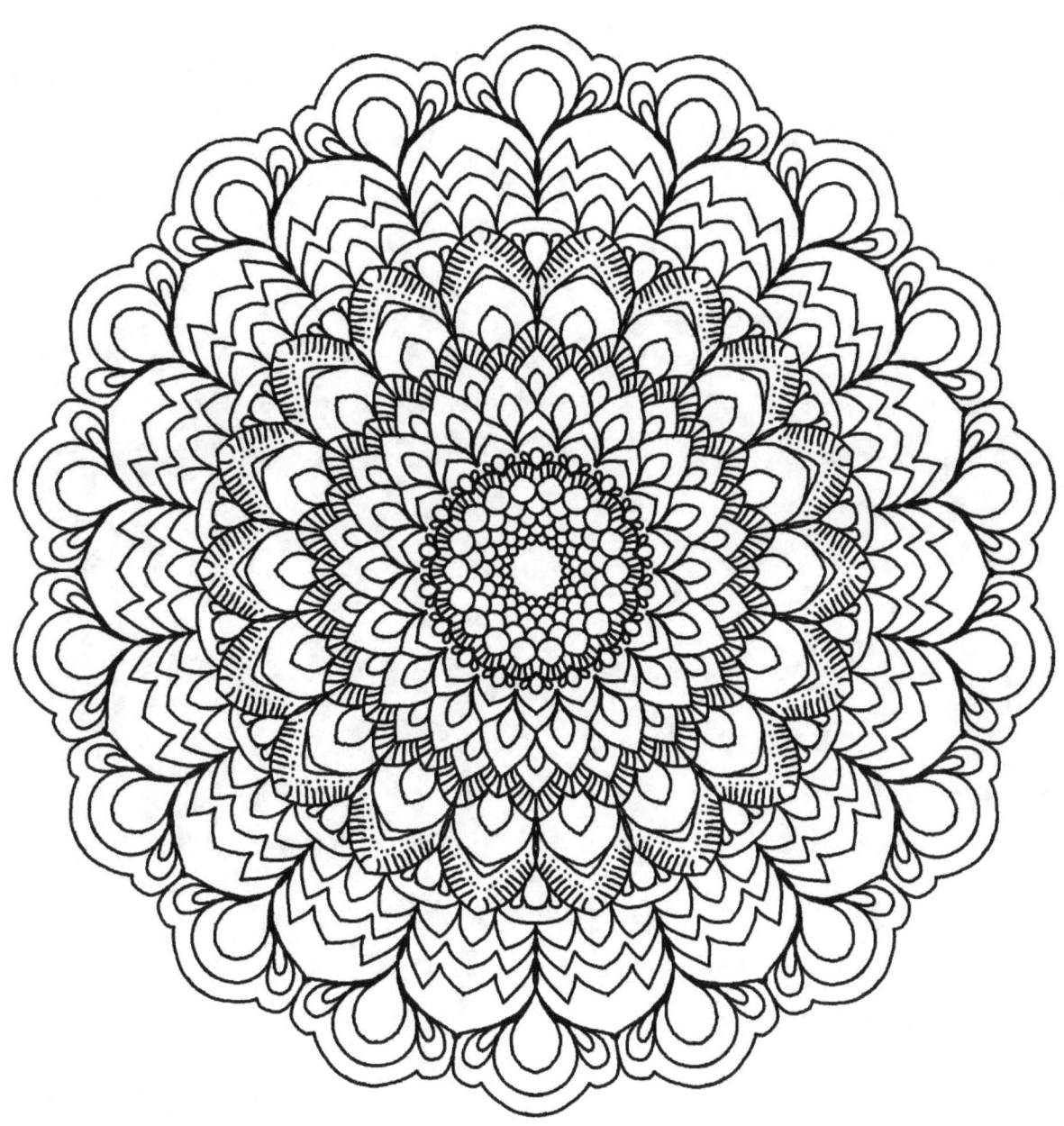

LOUISE ATHERTON

Revelation

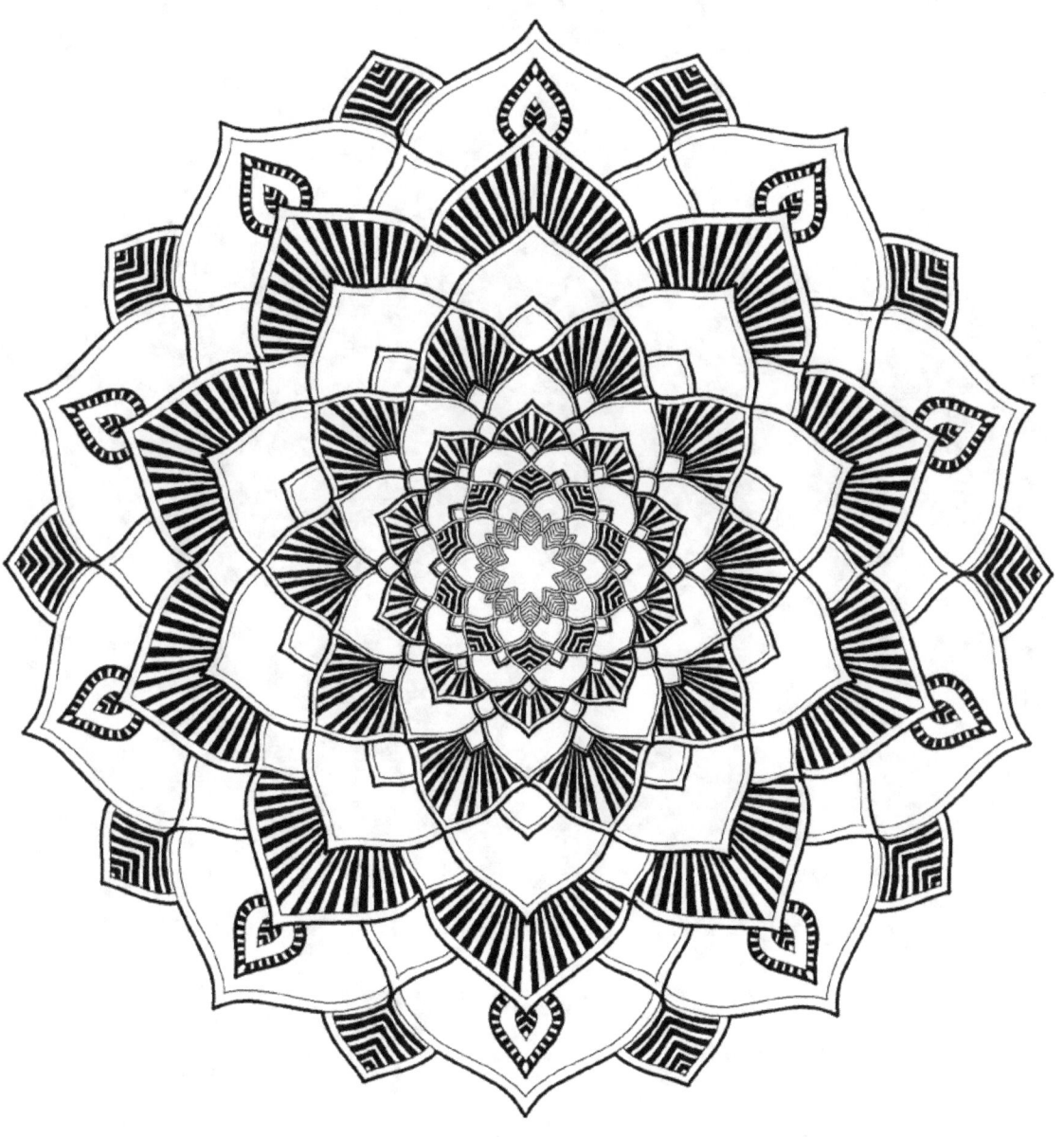

LOUISE ATHERTON

Reveal

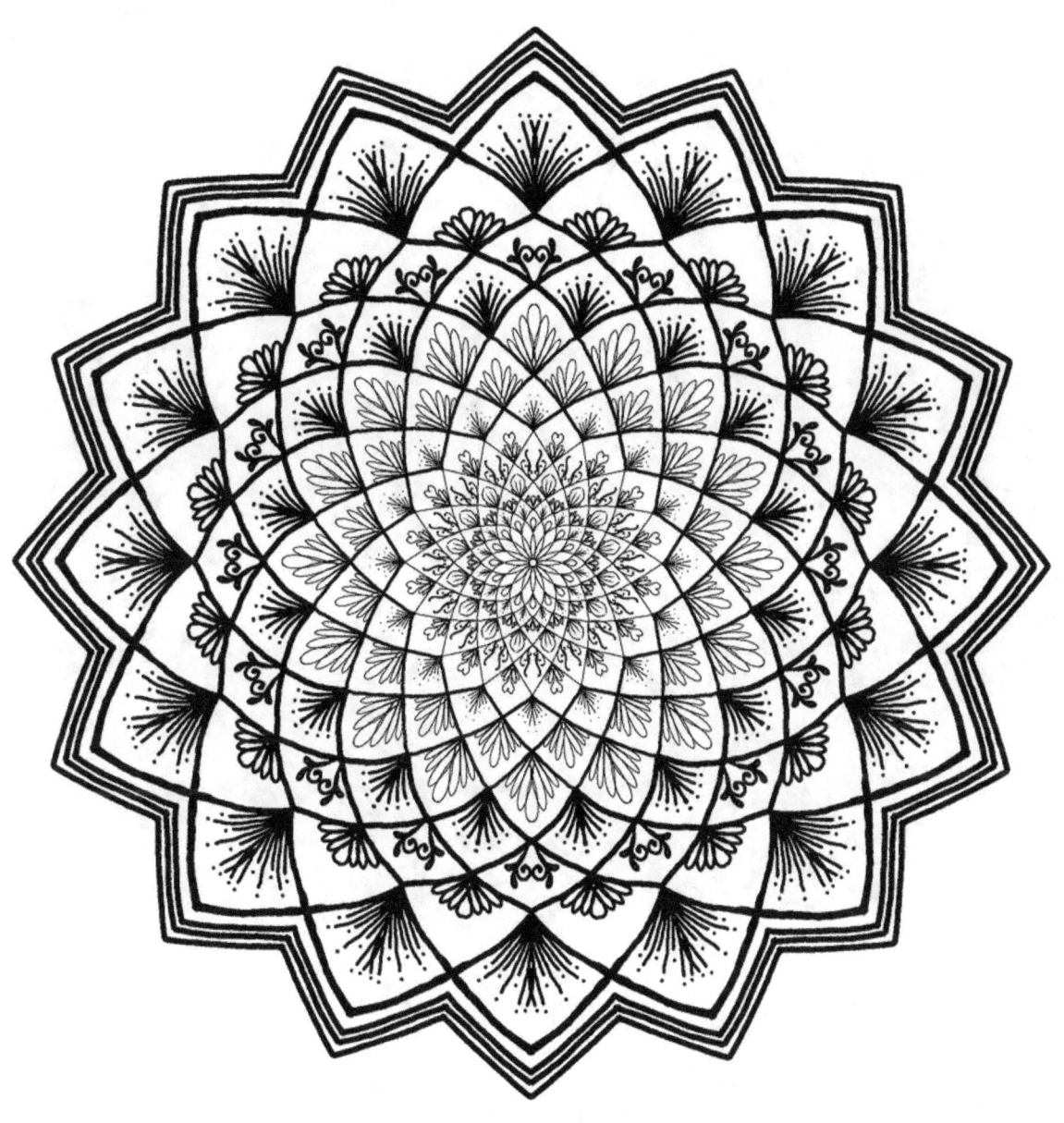

Smooth

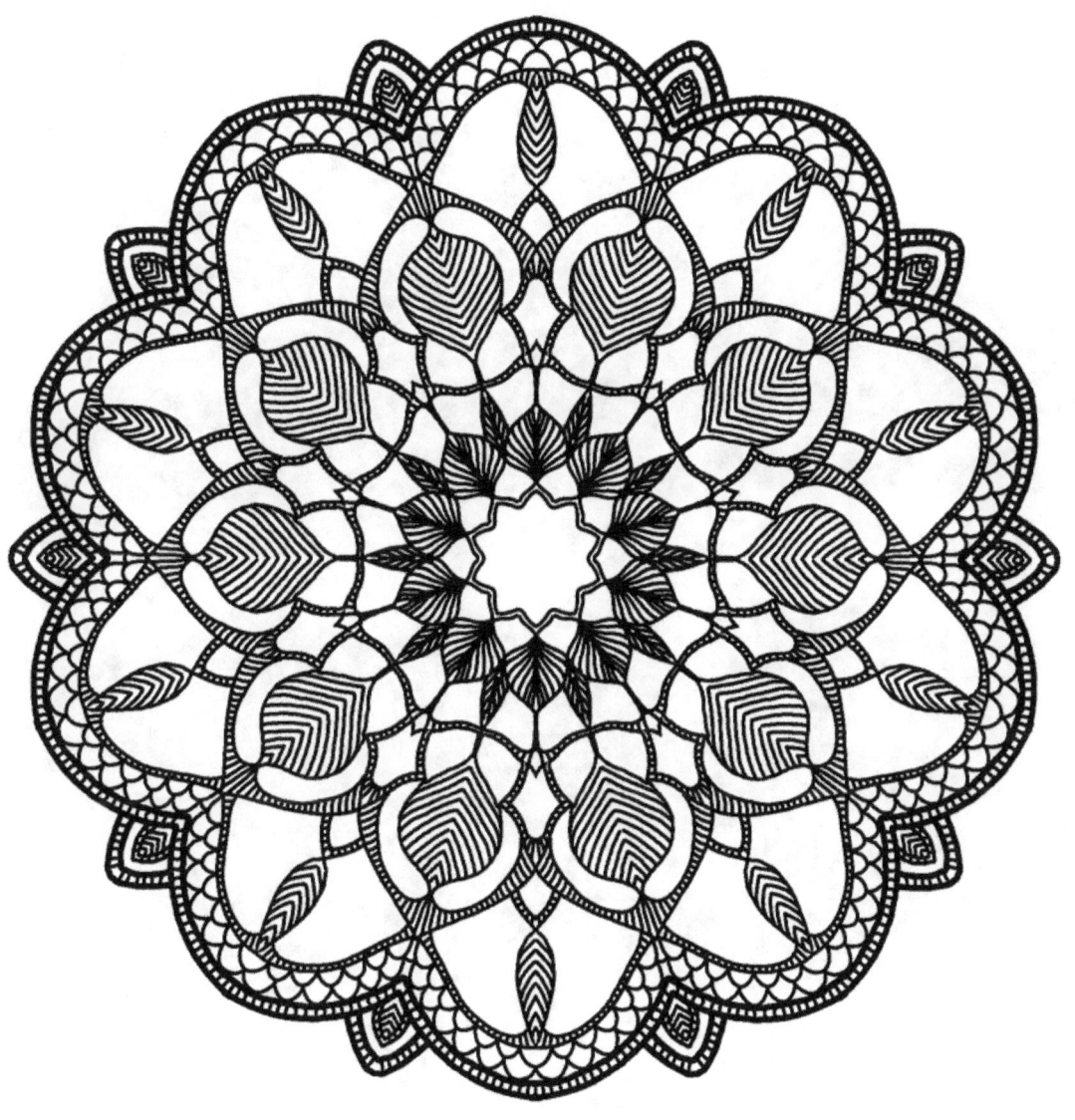

Pleasing

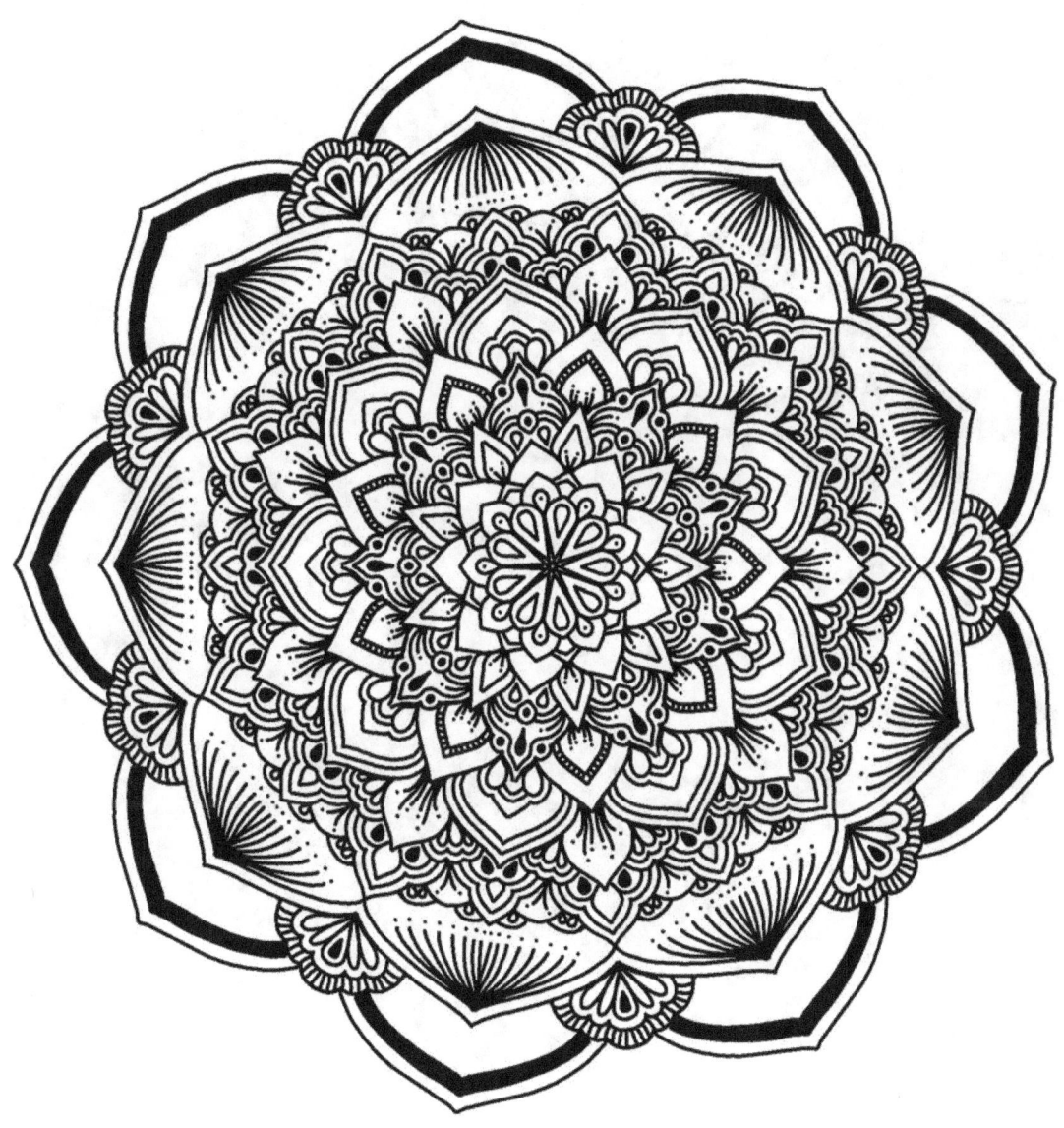

LOUISE ATHERTON

Sweetness

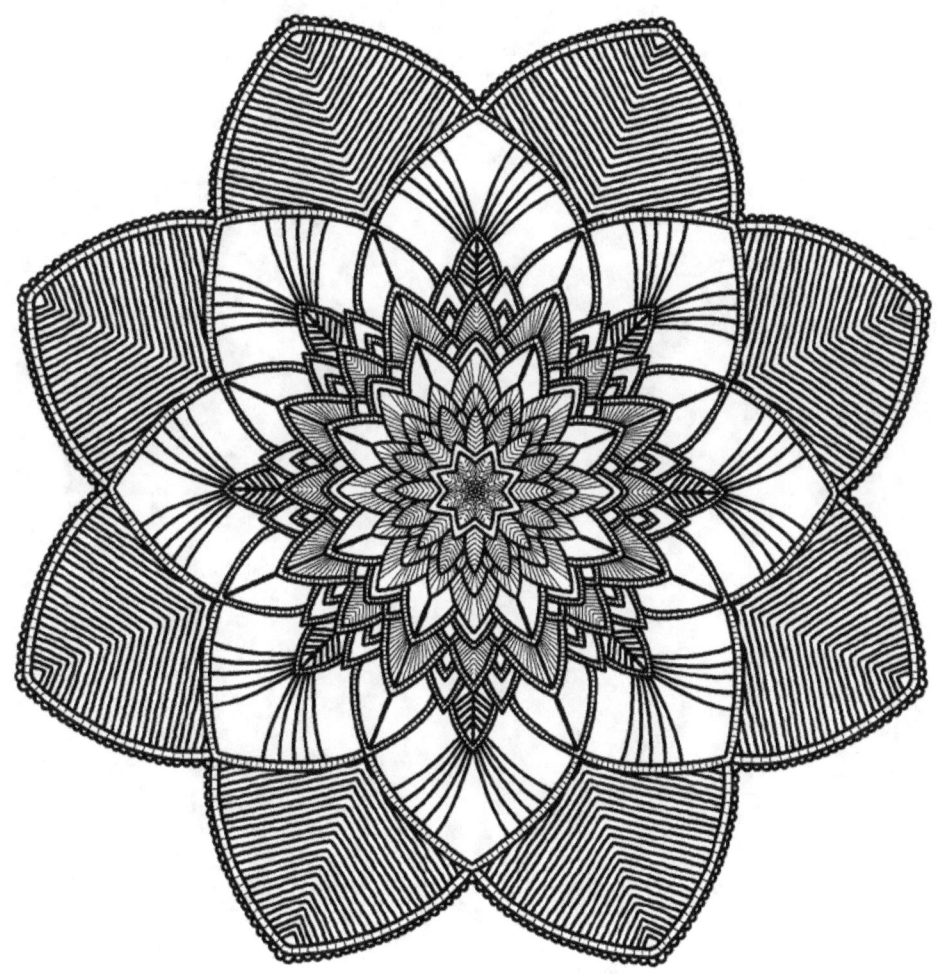

Pleasure

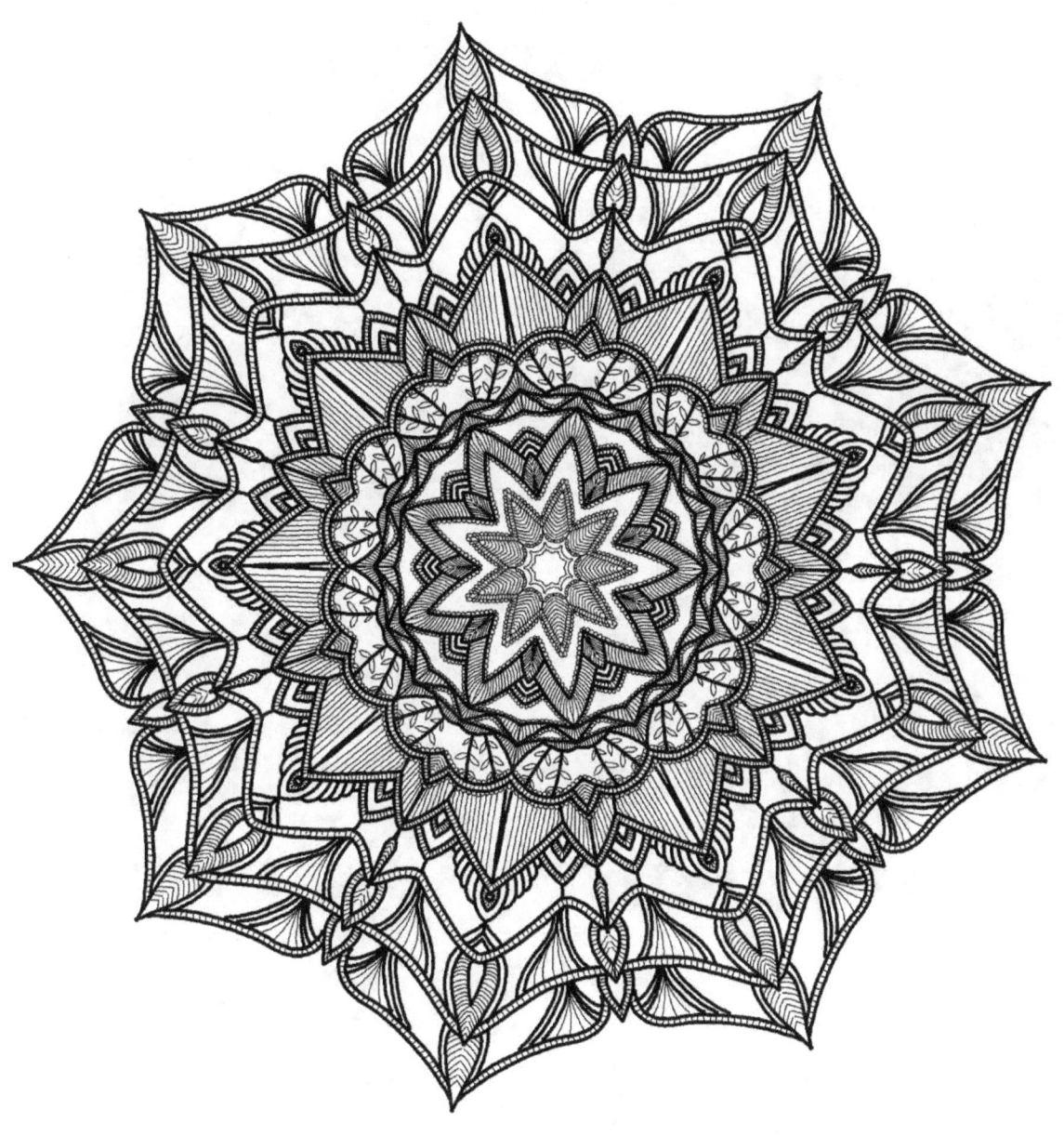

LOUISE ATHERTON

Homesick

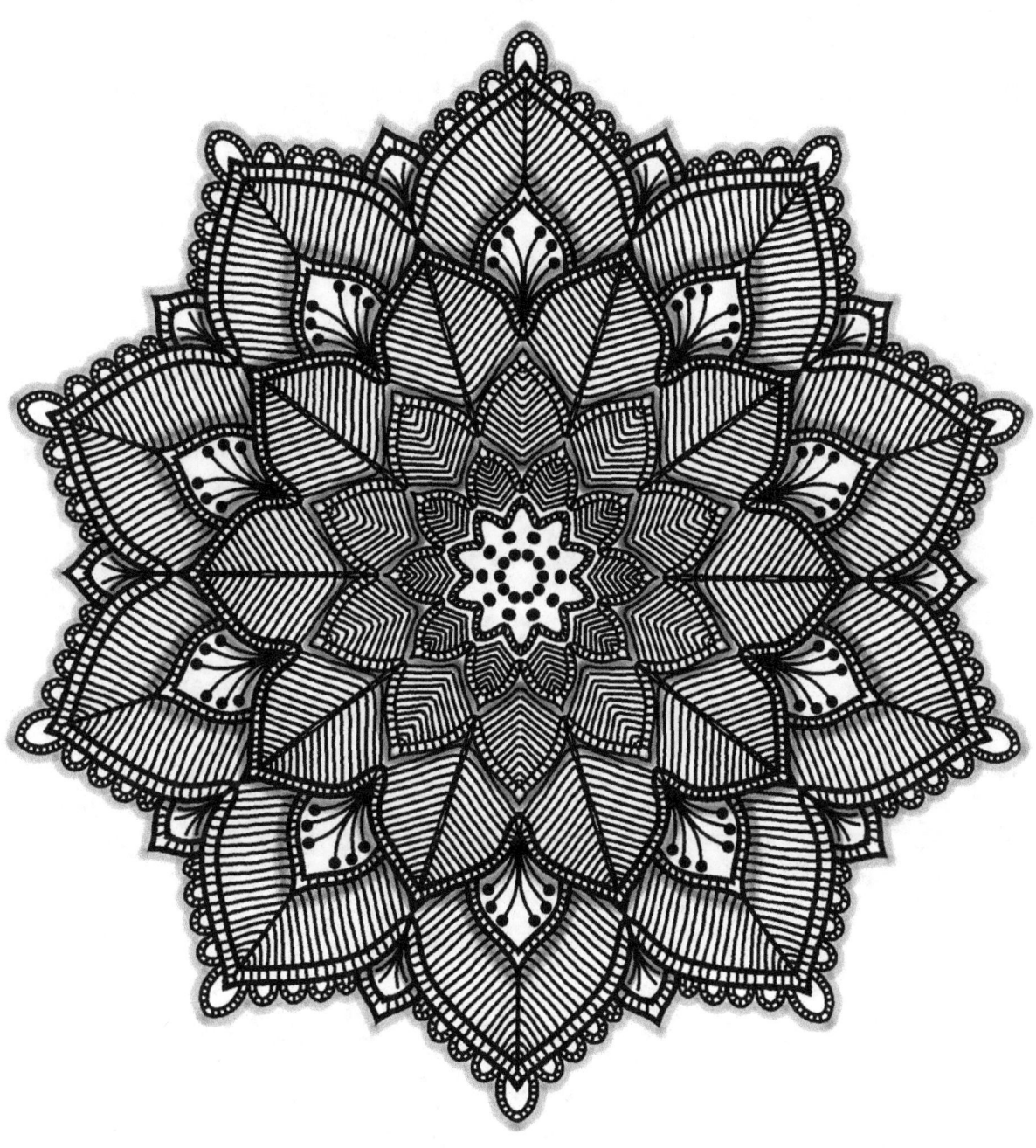

LOUISE ATHERTON

Slumber

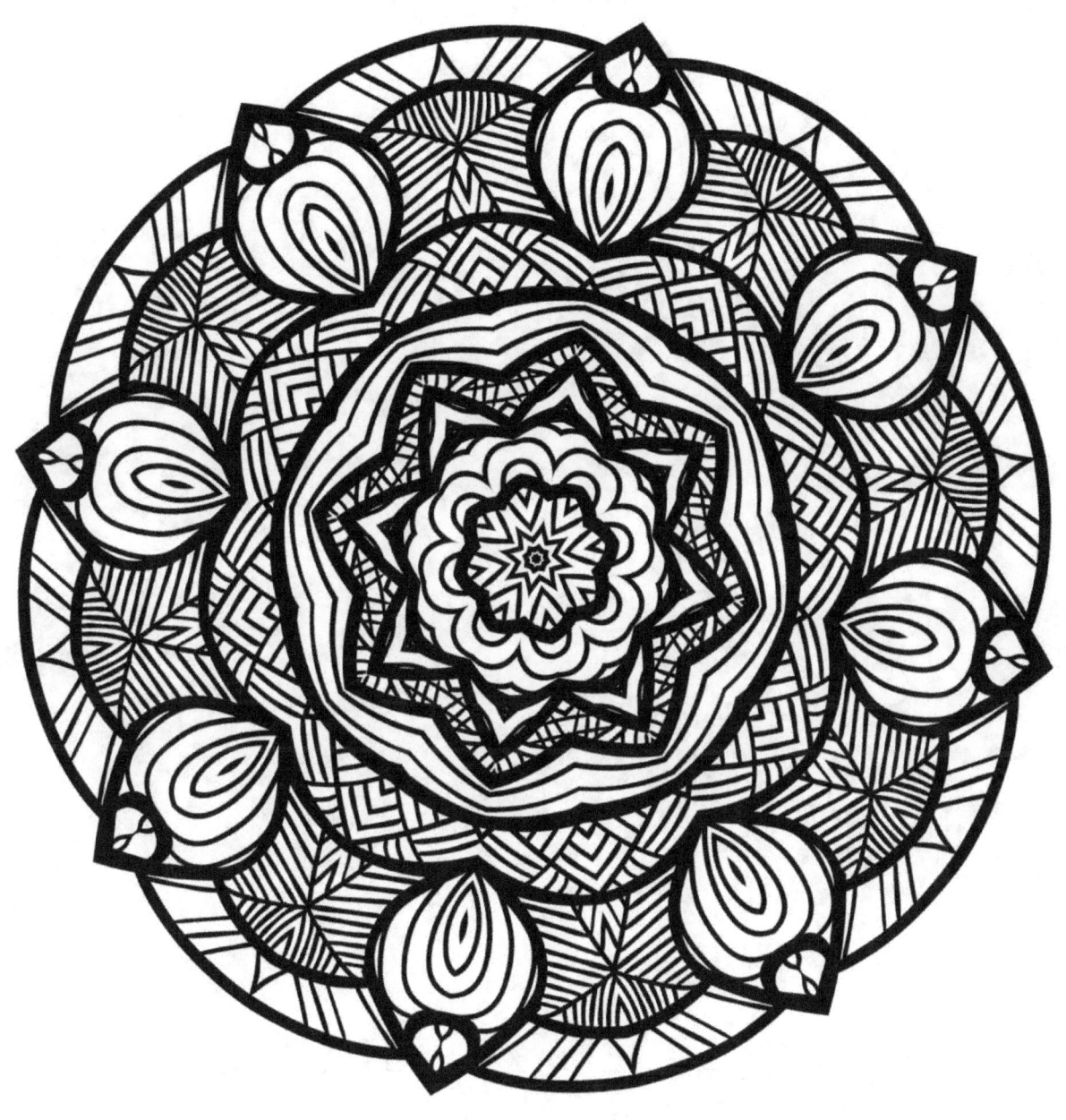

… LOUISE ATHERTON

Warmth

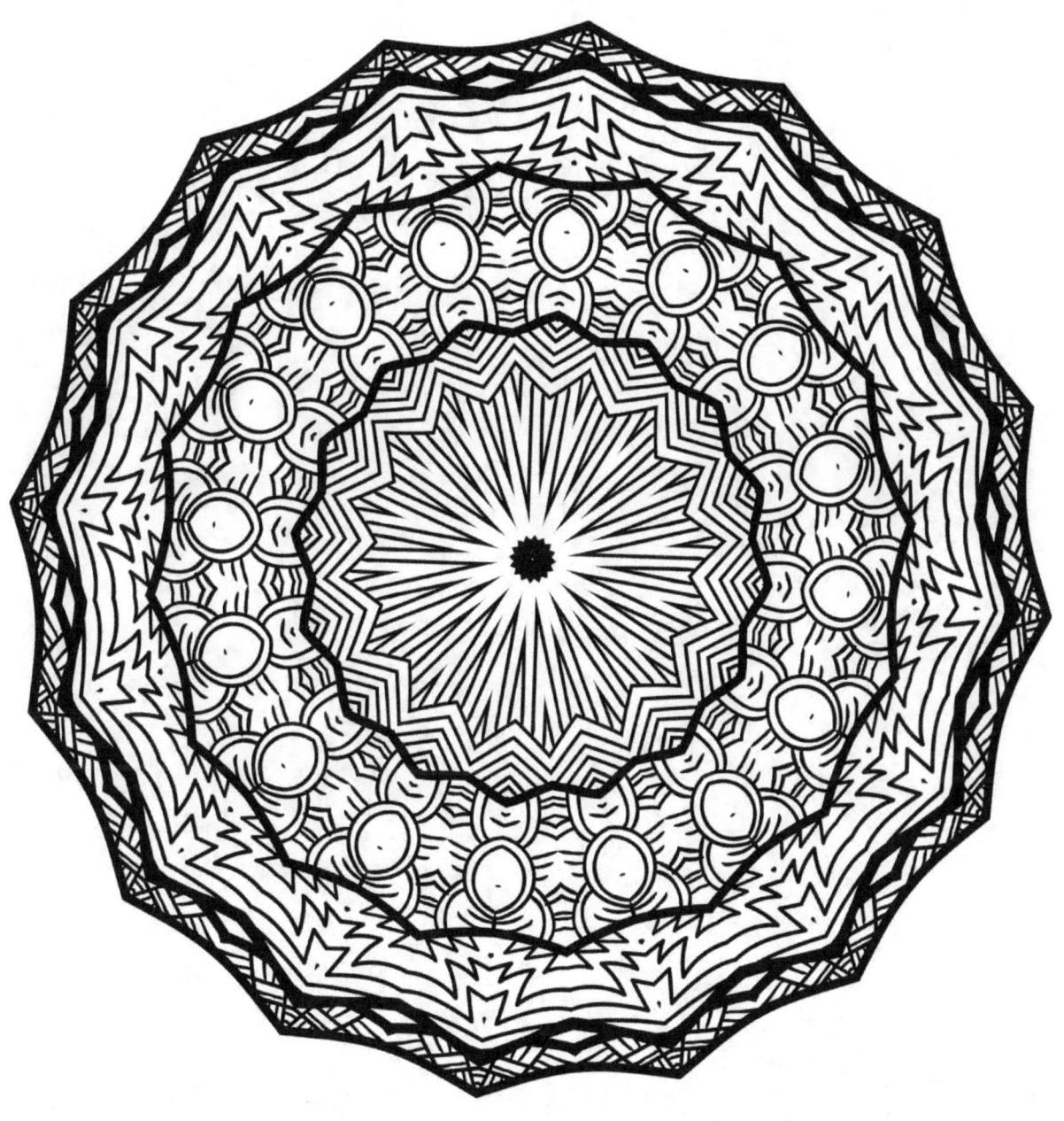

Nostalgia

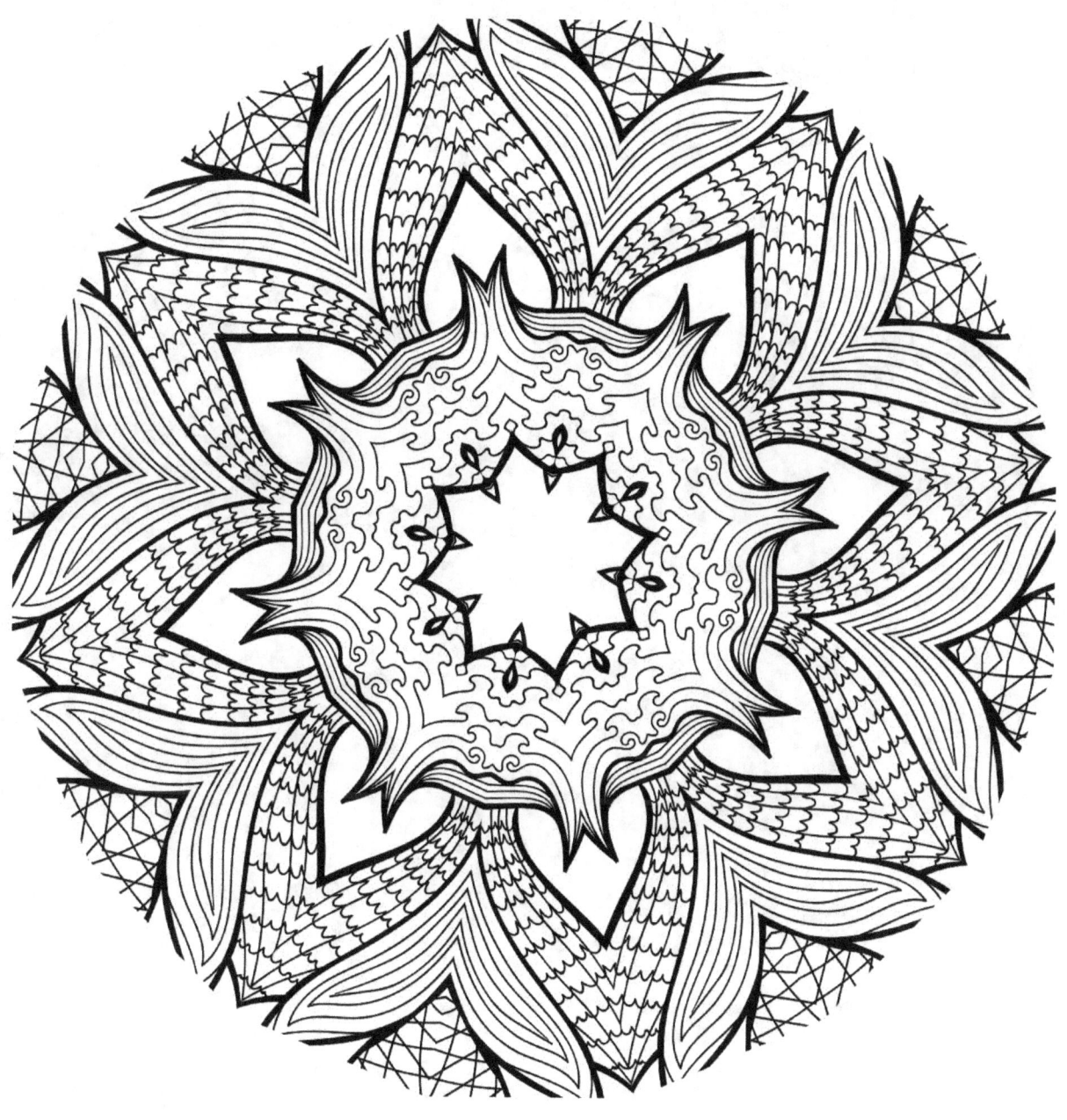

LOUISE ATHERTON

Grasp

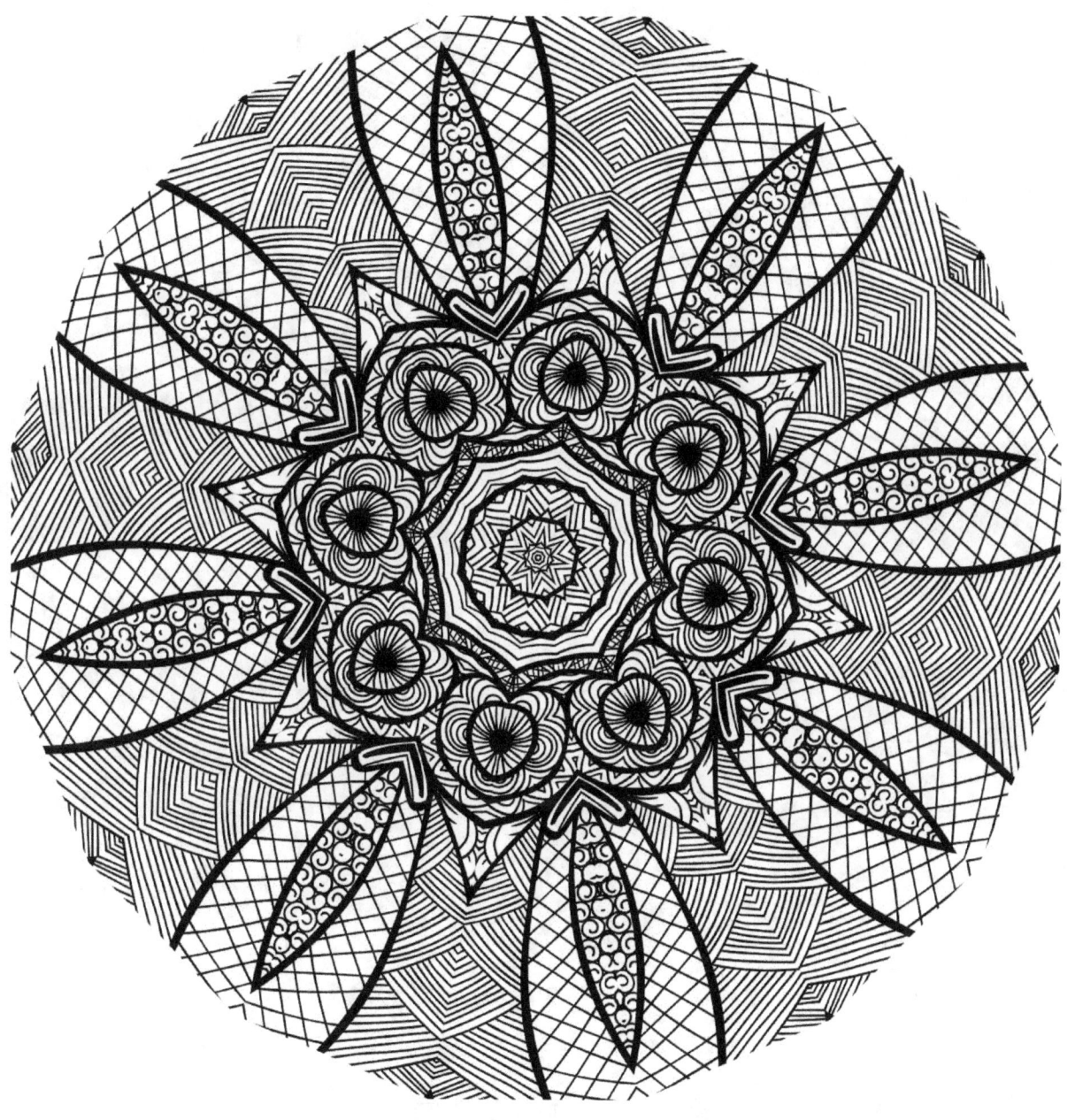

LOUISE ATHERTON

Wishing

www.ingramcontent.com/pod-product-compliance
Lightning Source LLC
Chambersburg PA
CBHW081122180526
45170CB00008B/2966